CLAY LANCASTER'S KENTUCKY

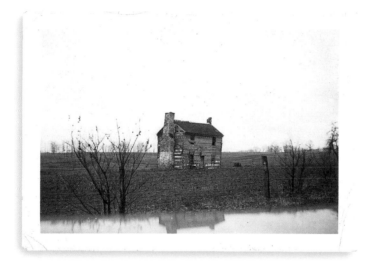

CLAY LANCASTER'S KENTUCKY

Architectural Photographs of a Preservation Pioneer

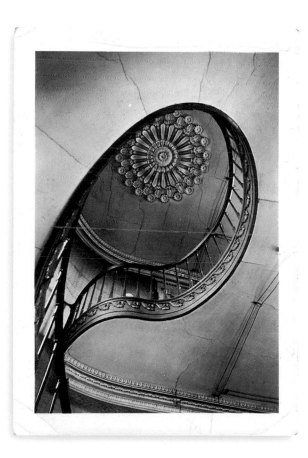

With best wishes
James D Birchfield

James D. Birchfield Foreword by Roger W. Moss

The University Press of Kentucky

Publication of this volume was made possible in part by a
grant from the National Endowment for the Humanities.

Photograph on p. 11 by Lisa Basch, courtesy of Warwick Foundation.
All other photographs courtesy of the University of Kentucky
Library's Special Collections.

Scholarly publisher for the Commonwealth, serving Bellarmine
University, Berea College, Centre College of Kentucky, Eastern
Kentucky University, The Filson Historical Society, Georgetown
College, Kentucky Historical Society, Kentucky State University,
Morehead State University, Murray State University, Northern
Kentucky University, Transylvania University, University of Kentucky,
University of Louisville, and Western Kentucky University.

Editorial and Sales Offices: The University Press of Kentucky
663 South Limestone Street, Lexington, Kentucky 40508-4008
www.kentuckypress.com

11 10 09 08 07 5 4 3 2 1

Library of Congress Cataloging-in-Publication Data
Birchfield, James D.
 Clay Lancaster's Kentucky : architectural photographs of a
preservation pioneer / James D. Birchfield ; foreword by
Roger W. Moss.
 p. cm.
 ISBN-13: 978-0-8131-2421-6 (hardcover : alk. paper)
 ISBN-10: 0-8131-2421-2 (hardcover : alk. paper) 1. Architectural
photography—Kentucky. 2. Lancaster, Clay. I. Title.
 TR659.B56 2006
 779'.4769—dc22 2006012091

♾ This book is printed on acid-free paper meeting the requirements
of the American National Standard for Permanence in Paper for
Printed Library Materials.

Designed by Todd Lape / Lape Designs

Manufactured in China

 Member of the Association of
American University Presses

FOR MARTHA

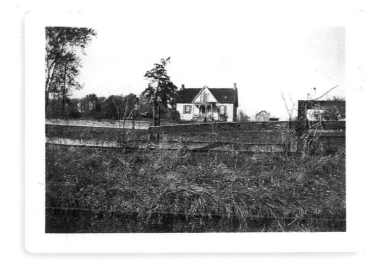

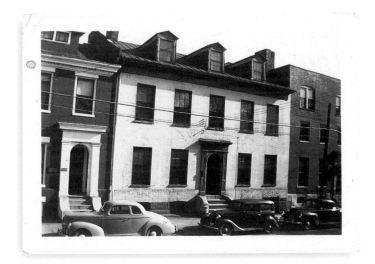

CONTENTS

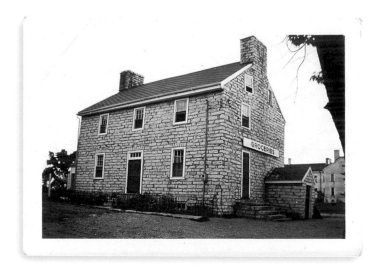

FOREWORD

In a candid moment, many architectural historians will admit to an early career of trespass and housebreaking. No less a figure than the renowned author John Harris, OBE, former head of the Royal Institute of British Architects Drawing Collection, even subtitled his 1998 autobiography *Confessions of a Country House Snooper*. And since I'm among friends, I might as well admit to my own career of crime in the 1950s when, like Clay Lancaster two decades before, I jumped many fences to reach abandoned houses in danger of being torched by vagrants or pulled down by a farmer's tractor. Our intent was not felonious; we certainly weren't there to wrest mantels from chimney breasts or gouge out H-L hinges. On the contrary, we were in search of something more precious: visual memories of authentic historic buildings untouched by vandalizing modernizers, well-intended restoration architects, or overzealous decorators. These memories, often reinforced by quickly snapped photographs, colored our careers as researchers, authors, and educators.

As James D. Birchfield traces in the following introductory essay, Clay Lancaster was infected by a love of architecture at an early age, a gentle madness from which he never cared to recover. Whether in Kentucky, New York, or Nantucket—all places he lived during a long and active life—Clay made a major contribution to the study and preservation of the local architecture. Following his death in 2000, his estate created the Warwick Foundation

to perpetuate his diverse interests, including his devotion to Kentucky's architectural heritage. As I remarked at the Warwick Foundation's inaugural event in 2003, "You could have dropped Clay Lancaster anywhere and he would immediately start surveying the local architecture and collecting early glass-plate negatives. And if there was no indigenous architecture, he would whip out his sketch pad and invent some." I might have added that his surveying would most likely include taking informal photographs such as those reproduced in this book.

For architectural historians like Clay Lancaster, a sharply focused, unretouched photograph is *documentary evidence* of the highest order. A "document," according to my desktop dictionary, is something that "furnishes conclusive information or evidence, as an original, legal, or official paper or record." Antiquarians have been documenting buildings photographically since Louis Daguerre (1789–1851) discovered the process that carries his name. Back when photography required bulky cameras, glass plates, and long exposures, many of the earliest surviving images are of buildings, probably because they could be captured in bright light and didn't fidget.

By the mid-nineteenth century, photographers in Europe, Britain, and America were purposely creating documentary photographs of ancient buildings that were being demolished to make way for underground sewers, subways, and grand boulevards. (There was even a Society for Photographing Old London Relics in the

1870s and 1880s that produced large-format prints of endangered structures.) Photographers and social reformers such as Jacob A. Riis (1849–1914) produced documentary images that revealed the unvarnished truth of the squalid New York City slums occupied by newly arrived immigrants. Horrified by what he saw, Riis dedicated his life to bettering the living conditions of the poor. Likewise, William H. Jackson (1843–1942) captured the phantasmagoric wonders of Yellowstone in Wyoming to convince a doubting Congress that such an extraordinary place actually existed and deserved protection as America's first national park. In the age before digital manipulation, the photograph did not lie.

By the late 1930s, when Clay began recording the work of John McMurtry for his master's thesis, photographic documentation of vernacular architecture for its own sake was under way. The invention of roll paper film and inexpensive cameras in the 1880s benefited both the tourist and the architectural historian. Large, heavy cameras, tripods, and specialized knowledge of chemicals for plate preparation and development were no longer required. As Mr. Birchfield points out, historians such as Henry Chandlee Forman (1904–1991) and Thomas Tileston Waterman (1900–1951) were already prowling the back roads and byways of Maryland and Virginia, informally recording abandoned and endangered manor and plantation houses. Waterman published his *Domestic Architecture of Tidewater Virginia* in 1932, and Forman's *Early Manor and Plantation Houses of Maryland* appeared in 1934. Both these landmark books would have been known to Edward W. Rannells at the University of Kentucky, who suggested that Clay write his thesis on John McMurtry, a topic that required a daunting amount of original research and photography. In addition, Forman and Waterman were contemporaries and friends of Charles E. Peterson (1906–2004), who drafted the New Deal scheme to employ out-of-work architects that became the Historic American Buildings Survey. HABS continues to function and has created the largest collection of documentary architectural photographs and drawings in the world, housed at the Library of Congress.

As important as HABS has been in recording the architectural patrimony of America, the program understandably focused—until fairly recently—on the key historic monuments in all the states and territories. There was no budget or staff to produce measured drawings and photographs of the thousands of rapidly disappearing vernacular buildings found throughout the older settled states such as Kentucky. This is why Clay's photographs are so important. He did more than document the obvious high-style structures, however. Many buildings that we treasure today were unappreciated in the 1930s and 1940s, as Clay's photographs of the John Pope Villa in Lexington (pages 35–36) and Pleasant Lawn in Woodford County (pages 62–63) graphically illustrate. His photographs often poignantly remind us of the terrible losses in the years before the founding of the Blue Grass Trust, such as Mount Airy in Woodford County (pages 50–51) and the more recent vandalism at Mount Brilliant and Plancentia in Fayette County (pages 48–49). Can any preservationist look at this sorry litany of lost Kentucky without shedding a tear?

Even when the buildings that Clay photographed more than sixty years ago do happily survive—now in the hands of house-proud owners—we still treasure Clay's photographs for the record of original features that may have been lost, changed, or obscured in the process of turning these buildings into twenty-first-century homes. Restoration architects, architectural historians, and owners of Kentucky's historic buildings will particularly appreciate Clay's photographs of ephemeral details such as chimney caps, porch steps, garden walls, and fences.

Mr. Birchfield correctly points out that Clay did not see himself as a professional photographer. He certainly did not expect to publish these images; they were site-visit field notes to jog his memory or to be used for reference when he drew the buildings later. In most things, Clay was a compulsive organizer and cataloger, whether of books in his library or a family collection of

shoes. Knowing how meticulous he was, I was surprised one evening at Warwick when he showed me some of his research notes. Clipped to index cards were the unenlarged contact sheets he had created with a modest, handheld camera decades before. Many of the photographs were identified and dated, but then somewhat carelessly jammed into file boxes. Without magnification, especially in the dim light of the Moses Jones House, the images were virtually impossible to study, and they might easily have been lost or ignored after his death.

With modern digital technology, however, it was possible to scan these diminutive photographic prints without loss of detail and then enlarge and enhance them for reproduction in this volume. Through this process, many buildings long forgotten (or altered beyond recognition) have been saved from total oblivion. We now have another reason to be grateful for Clay Lancaster's many contributions to our understanding of Kentucky architecture.

—ROGER W. MOSS

Roger W. Moss, Ph.D., is executive director of The Athenaeum of Philadelphia, adjunct professor of architecture in the Preservation Program of the University of Pennsylvania, and author of a dozen books on architecture and design. He was a longtime friend and admirer of Clay Lancaster.

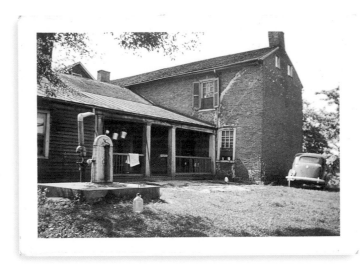

ACKNOWLEDGMENTS

I would like to thank the following for their interest and assistance: Laurel Garrett, former president of the Warwick Foundation; Joyce Harrison, editor-in-chief of the University Press of Kentucky; Roger W. Moss, director of The Athenaeum of Philadelphia; Patrick Snadon, University of Cincinnati College of Architecture; architectural writer Bettye Lee Mastin; Richard S. DeCamp, former director of the Lexington-Fayette County Historic Commission; Mary Winter, curator of Special Collections at the Kentucky Historical Society, Frankfort; Charles Pittinger, curator of the J. B. Speed Art Museum, Louisville; Peter E. Prugh, director of the University of Florida's Preservation Institute: Nantucket; Faith Harders and Lalana Powell of the Hunter M. Adams Library, College of Design, University of Kentucky; Peggy McAllister, curator of the Central Library Gallery, Lexington Public Library; Martha Birchfield, who has served on a number of historic preservation boards; Bettie L. Kerr, director of the Lexington-Fayette Urban County Office of Historic Preservation; the late Burton Milward, Lexington historian; and the Kentucky Humanities Council.

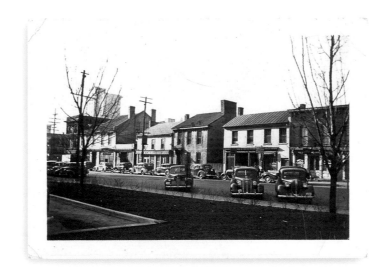

INTRODUCTION

When Clay Lancaster was four years old, a bronze sculpture featuring his figure was installed on the courthouse lawn in Lexington, Kentucky.[1] Since 1921, the effigy of this future polymath has stood between two bronze generals—John Hunt Morgan and John C. Breckinridge—monumentalized as a public work of art. It was a fitting beginning, for Lancaster was absorbed with the arts all his life, and his involvement with the creative impulse never left him. Clay Lancaster is remembered as a scholar, a critic, an architectural historian, an orientalist, an author of books for children, an artist, an illustrator, a cartographer, an art collector, and even a stage designer,[2] but he is not known as a photographer. Yet he generated thousands of photographs, including approximately three thousand images of Kentucky architecture, and these form an important part of his legacy.

Lancaster was a graduate student in the art department at the University of Kentucky in the late 1930s when Edward Warder Rannells suggested that he write his master's thesis on John McMurtry, a nineteenth-century Lexington builder and architect.[3] There was no College of Architecture in those days, and the project fit into the general fine-arts area that fascinated Lancaster. McMurtry (like Lancaster) was both a genius and indefatigable; he generated numerous patents, ran a lumberyard, and erected so many buildings in Lexington that it would take a book to describe them all. Lancaster wrote that book, *Back Streets and Pine Trees: The Work of John McMurtry*, which grew out of his thesis. It was published by Carolyn Reading Hammer and Amelia Buckley's Bur Press in 1956, and it was hand set and hand printed at Hopemont, the John Wesley Hunt House, on oriental paper in a limited edition of 250 copies. Rich in scholarship as well as an exquisite achievement in book art, *Back Streets and Pine Trees* has justly become a valued rarity.

To prepare his manuscript, Lancaster had to research McMurtry's work, which involved surveying and photographing all the examples he could identify. It is inspiriting to picture the young Clay Lancaster combing the city and the countryside, reviewing deeds, collecting data, making notes, and seeking out old photographs and creating new ones. He knocked on antebellum doors, crawled through antebellum windows of abandoned structures, measured antebellum facades and rooms, counted windowpanes, recorded masonry patterns, and sought lore on every known McMurtry building. He photographed buildings inside and out; sometimes he even photographed the roof. With the aid of a Guggenheim grant, Lancaster later extended his work on McMurtry to antebellum Kentucky buildings in general, although his interest lay largely with the quality rather than the age of the structure.

Others were at work on similar projects. In Maryland, as early as the 1930s, Henry Chandlee

Forman was combining text with his own photographs to outline the state's historic structures. In 1941 the University of North Carolina Press produced a photographically illustrated book titled *The Early Architecture of North Carolina*, a collaboration between the well-known photographer Frances Benjamin Johnston of New Orleans and architectural historian Thomas Tileston Waterman (who later surveyed Virginia architecture). In the preliminaries, these eminent figures ponderously note that "the making of this book has been a particularly difficult task, as the research was all pioneering in an unexplored field where there was no precedent to follow." They continue, "It is only during the last ten years that the support given by the Carnegie Corporation of New York has made possible Miss Johnston's magnificent photographic records of southern architecture, and it is only by the establishment of the Historic American Buildings Survey that Mr. Waterman has been able to carry out the . . . intensive study necessary to make clear the threads in a tangled web."[4] Clay Lancaster produced an even more refined record without the Carnegie Corporation and the Historic American Buildings Survey, relying on just a simple camera and the encouragement of family and friends.

When considering what Lancaster accomplished, it is important to remember the broader context. This was during the Great Depression, and various kinds of government-sponsored surveys and projects were afoot. Typical was the Historical Records Survey, which included, for example, the *American Imprints Inventory* conducted by Douglas C. McMurtrie. McMurtrie and his colleagues attempted to identify all the early books produced in various states; in Kentucky, this began with John Bradford, the first Kentucky printer.[5] From 1935 to 1943 the Farm Security Administration sponsored photography projects on agricultural subjects; for Kentucky, these photographs have been collected in *A Kentucky Album*, edited by Beverly Brannan and David Horvath.[6]

Another key survey project was the Historic American Buildings Survey (HABS), initiated by the Historic Sites Act of 1935. This represented an effort to enumerate and describe all kinds of historic structures, including courthouses, bridges, covered bridges, churches, mills, and residences. One product of this endeavor was a series of plaster of paris models of Kentucky buildings and bridges. Lancaster completed his thesis on John McMurtry in 1939; however, the first HABS visit to Lexington was a year afterward, in the summer of 1940, when a team arrived to document Loudoun House, a task that must have been facilitated by Lancaster's previous work.[7]

Public projects aside, however, there were others in and outside Lexington who were interested in buildings, especially residences. One was C. Frank Dunn, who collected photographs of old buildings and carried out a tremendous amount of research in the deed books. He compiled a typescript, "Old Houses of Lexington," but it was never published. A great enthusiast and promoter of preservation, Dunn wrote newspaper features on old houses, published lists of the oldest structures, and relished occasional arguments in the press.[8] Dunn was also the editor of *Kentucky Progress Magazine* and made architecture an ongoing feature of that publication. Dunn was devoted to pictorial as well as factual investigation, and his personal collection of photographs is at the Kentucky Historical Society.

As a youth, Lancaster studied in a circle of artists that included Dr. Waller Bullock, an amateur sculptor who lived at the Bodley-Bullock House in Gratz Park in Lexington. Bullock was also a collector of architectural photographs, and his collection is now in the Transylvania University Library. Lancaster occasionally relied on photographs from Bullock's collection for his research.

Another devotee of old Lexington photographs was Charles Staples, a member of the prestigious Book Thieves club and author of *The History of*

Pioneer Lexington (1939).[9] His collection has vanished. Another member of the Book Thieves was J. Winston Coleman, an avid collector whose archive of old photographs, like Dr. Bullock's, is at Transylvania. (We should remember that our library research collections developed out of the work of these collectors; the University of Kentucky Library's Special Collections began in 1946 with the death of Judge Samuel M. Wilson, another member of the Book Thieves and a photograph collector.) Coleman is also important because, beginning in 1948, he published two newspaper series entitled "Historic Kentucky"; in 1968 a book of the same title assembled a selection of his illustrated articles.[10] In addition to collecting photographs, Coleman was an active photographer himself and a member of the very productive Lexington Camera Club, created in 1936, just before Lancaster embarked on his work on McMurtry.[11] One member in particular, Professor Edward Nollau of the College of Engineering at the University of Kentucky, took many photographs of Lexington structures in the 1930s and 1940s, but his work apparently was not available to Lancaster. Nollau's prints and negatives, including many glass plates, are now in Special Collections at the University of Kentucky.

Less well known was a group similar to the Book Thieves called the Thigum Thu, which centered on the interests and collections of Colonel James Roche, a colorful utilities magnate.[12] Unfortunately, Roche's rich store of Kentucky imprints, newspapers, letters, busts, art, and records was not retained as a collection (or perhaps at all), and today the Thigum Thu remains only an amusing name. Lancaster acknowledged Roche's assistance by recalling that the colonel, who was born in Harrodsburg and came to Lexington in 1864, actually knew both John McMurtry and Thomas Lewinski, the chief nineteenth-century architects in central Kentucky.[13]

Now unremembered, but significant, was yet another collector of photographs, Abraham B. Lancaster, an uncle of Clay's who died in 1923. A. B. Lancaster assembled an extensive collection of images of local structures that is now housed at the Lexington Public Library. Clay certainly would have been conscious of his kinsman's devotion to preserving historic architectural views, and this awareness may have stimulated Clay's interest in generating his own series of historic architectural photographs.[14] Like his uncle, Clay collected a number of antique prints during the course of his research, and he sought others among private and institutional holdings.

From the 1930s to the 1950s, several important works on early Kentucky buildings, chiefly houses, were published. These included two books written by Mrs. Elizabeth Simpson: *Bluegrass Houses and Their Traditions* (1932) and *The Enchanted Bluegrass* (1938). Both were collections of articles that Simpson originally wrote as newspaper features, and both books were illustrated with photographs from professional photographers in the region—Frank Long of Lafayette Studio, Eugene Bradley of the Bradley Studio in Georgetown, Cusick Studio of Frankfort, Deacon Studio, J. A. Estes, and L. S. Sutcliffe. Another important writer on Kentucky architecture during this period was Professor Rexford Newcomb of the University of Illinois, whose two books—*Old Kentucky Architecture* (1940) and *Architecture in Old Kentucky* (1953)—were also illustrated with photographs. Newcomb's books were the only ones offering images by a professional architectural photography firm—Tebbs & Knell of New York. Newcomb's Tebbs & Knell negatives, found in a barn in Illinois, are now at the Kentucky Historical Society; sets of prints are available there as well as at the Filson Historical Society in Louisville. In a related development, in the fall of 1933 (shortly after the appearance of Mrs. Simpson's first book), C. Frank Dunn began a series of architectural features in *Kentucky Progress Magazine,* and prior to this, Dunn had already been commissioning photographs from Robert W. Tebbs of Tebbs & Knell for this publication.

All those writing on Kentucky architecture in newspapers, magazines, and books were using photographs for illustrations, with a single exception. Walter Kiser, a feature writer for the *Louisville Times* in the 1930s, made pen drawings to accompany his newspaper narratives.

Although Clay Lancaster took photographs, he did not think of himself as a photographer; he thought of himself as an artist. As an artist and as an architectural historian, he prepared two types of drawings. The first were delicately shaded pencil drawings; his friend, the Vienna Academy trained artist Victor Hammer, would have called these "precise drawings." They were practically photographic in their nuances and delicate attention to shadow and detail. The second were simple line drawings that recorded the basic outline of a building and dispensed with any effort to deal with the realism of light and shadow. These drawings were more akin to the woodcut representations accompanying the writings of Italian architect Andrea Palladio, whereas the shaded drawings were more reminiscent of the Roman views of Giambattista Piranesi, made possible by the later and more subtle process of working burins and rockers on copper plates.

For those attracted to the economy, precision, and detail of Clay Lancaster's drawings, his methods of work have been well recorded by Professor Patrick Snadon of the University of Cincinnati, who observed Lancaster both in the field and at his drawing table:

> When visiting a building site, Lancaster typically worked alone and took all his dimensions and field measurements with a little folding wooden rule. Then, when doing his architectural drawings (floor plans, elevations, sections, perspectives, etc.), he did not use a drafting board and the standard equipment of his era (such as T-squares, triangles, architect's scale, etc.), but employed only a tiny ruler (usually only six inches long) which he used to make parallel tick-marks in pencil, measuring from one edge of a sheet of high-quality paper—which served in place of the parallel and grid lines derived from drafting T-squares and triangles. He created architectural drawings with a process more akin to that of an artist than that of a professional architect or draftsman.[15]

Snadon also points out that Lancaster's drawings were not limited to the usual repertoire of plans, elevations, and sections but included "more elaborate drawings, such as axonometric and cutaway drawings and diagrams." These are particularly well represented, for example, in his graphic analyses of McMurtry's Lyndhurst and Botherum.

As mentioned earlier, Lancaster's first book, *Back Streets and Pine Trees,* was printed on a hand press (by Victor Hammer's son, Jacob). As a rule, the hand press is poorly adapted to produce delicately shaded, or halftone, work. It does line work much more easily, and, according to Lancaster, it was Victor Hammer who suggested that he abandon his shaded drawings for simple line drawings. Although Lancaster's *Ante Bellum Houses of the Blue Grass,* published in 1961, was printed with processes that would have permitted halftones and shading, his representations of houses were once again all in line drawings, although he did include a few photographs in the appendix.

For his drawings, Lancaster relied on graphic sources—sometimes photographic, sometimes even lithographic—but his ideal product was the severe, unshaded, unnuanced line drawing. In his later works, *Vestiges of the Venerable City* and *Antebellum Architecture of Kentucky,* he used a mix of line drawings and photographs—both historical views and his own. He continued to make drawings for the rest of his life and generally seemed to prefer them to grayscale photography.

When preservationist Earl Wallace presented the Blue Grass Trust's John Wesley Hunt Award to

Lancaster in 1986, he spoke highly of the impact of Lancaster's scholarship and its contribution to historic preservation. In characterizing Lancaster's work, he stated that Lancaster had restored Kentucky's architecture with his pen. This was an apt observation. Whereas photographs necessarily record the various architectural accumulations and modifications that frequently scandalize a historical purist such as Lancaster, drawings can be less literal. With his pen, Lancaster could restore missing pinnacles, correct changes in windowpane patterns, modify rooflines, expunge additions, remove inconvenient plantings, and present a structure's original appearance based on the remaining evidence.

In the introductory essay to *Antebellum Architecture of Kentucky,* Lancaster affirms his idealism and his distaste for architectural modifications. He writes: "This present book deals with intangibles and concentrates on essences. It is pre-occupied with original forms rather than what buildings may have become later. The silent and crumbling ruins of the Parthenon hardly relay the intense devotion of the ancient Greeks to their goddess Athena." He goes on to mention modifications to the Boston Custom House and James Dakin's Bank of Louisville. "Guide books state these changes as facts. To the author they are desecrations, though the last is infinitely to be preferred to . . . destruction. . . . As built, they were full-voiced proclamations of architecture. As ruins, or segment, or compartment, they are less than half-statements."[16]

In his introduction to *Ante Bellum Houses of the Bluegrass,* Lancaster writes:

> The principal illustrations in the text . . . are line drawings. This medium has been chosen in order to present the essential features of each architectural composition free from the encumbrances of later alterations and additions which the camera cannot avoid recording. The illustrations are, in fact, compilations derived from reliable descriptions obtained through interviews with former residents, from modern and old photographs, and from personal investigations, including the measuring of existing monuments for plan and elevation sketches.[17]

One should remember that even Louis Daguerre was an artist—"a painter, printmaker, theatrical set designer, and maker of dioramas."[18] He no doubt used the camera obscura, an early device relied on by artists, but in his description of photography, Daguerre states, "The daguerreotype is not an instrument to be used for drawing nature [as is the camera obscura], but a chemical and physical process which allows nature to draw itself."[19] Daguerre does not observe, as does Lancaster, that photography also compels one to reproduce in a picture things one does not wish to see.

For example, compare the lithographic view of John McMurtry's arena for the Maxwell Springs Fair Association made from a panoramic map of 1857 with Lancaster's pen drawing based on this source. Lancaster's photograph of McMurtry's train station shows a building of three stories, but the line drawing used in *Back Streets and Pine Trees* shows a structure corrected to the original two stories. Furthermore, by creating drawings from photographs, Lancaster could produce composite drawings of clusters of buildings, such as his views of Gratz Park and of West High Street.[20]

Because of his early reliance on drawings, Lancaster tended to regard his own photography, and his research into early photographs, lithographs, and woodcuts, as merely an adjunct to drawing. Unlike the studio photographers who went out with large-format cameras and tripods, Lancaster went out with only a simple camera. He had no tripod, no light meter, no lamps, no flash, no reflectors, no wide-angle lenses, no close-up lenses, no swings, no tilts, no shifts, no rises, and no filters. He simply placed the camera on the floor, a table, a chair, or the car top and held the shutter as long as he thought necessary. He had no

darkroom; he took his film to the drugstore for routine processing and tiny 2¼ by 3¼ inch contact prints. He ordered no enlargements, but used only the little contact prints as a reference for his line drawings.

Lancaster's photographs show similarities to the work of other architectural and art photographers. One common feature is the absence of human figures. This attribute was characteristic of the late-nineteenth- and early-twentieth-century French photographer Eugène Atget, a former theater man who went about Paris with his large camera and glass plates recording the architecture of the city. A friend "told him which houses, which sites and chateaux, which spots were doomed to disappear. Paris and her old churches, her monuments, her miseries and her treasures were photographed by Atget."[21]

Another photographer prominent early in the twentieth century was the previously mentioned Frances Benjamin Johnston, who lived on Bourbon Street in New Orleans. She made portraits of Theodore Roosevelt, Mark Twain, and Booker T. Washington, as well as flashlight views of Mammoth Cave, Kentucky. She carried out projects to photograph old houses in North Carolina and Georgia, and her work is that of an expert commercial photographer. There is much to be said for her interesting photographs, but unlike Lancaster, she was not confined to available light and the moods of the shadows; her subjects are well chosen and fully illuminated.[22]

Whereas the work of Johnston was Apollonian, cerebral, and documentary, the work of Clarence John Laughlin of Louisiana (with whom Lancaster was acquainted) was Dionysian, full of emotion and deeper meaning. His work at times tended toward surrealism and in some cases was even suggestive of Lexington's Ralph Eugene Meatyard. Laughlin has been called "a mystic of the camera," but what is said of him might be said of Lancaster as well: "The past . . . breathes in his photographs where he has sought out the old, the fallen, and forgotten mansions of Louisiana and

preserved them in their poignant decay."[23] There was a major exhibition of Laughlin's work at Atlanta's High Museum in 2003, and the University of Louisville has an extensive collection of his prints.

Lancaster had no aspirations to be known as a photographer, but his gifts were such that he could not escape being an artist with the camera—even a cheap camera. This is particularly true of those early years during his discovery of Kentucky architecture—from the time of his thesis on John McMurtry in the late 1930s until his departure for New York in 1943. With his long exposures using only available light, he at times anticipates the later work of Linda Butler at the Shaker Village of Pleasant Hill, Kentucky.[24] Once in New York, Lancaster made his reputation as a lecturer at Columbia University, the Metropolitan Museum of Art, Vassar College, Cooper Union, and elsewhere. He largely turned from black-and-white work and began to make color slides. Color work is more forgiving in terms of the effects of light, and it is more literal in impact than black, white, and gray. Decades later, his Kentucky photographs served his needs when he returned to complete *Vestiges of the Venerable City* in 1978 and *Antebellum Architecture of Kentucky* in 1991. He occasionally made new photographic prints, but they typically lack the appeal of his work from the 1930s and 1940s.

Lancaster's early examination of Kentucky buildings—both his photographs and his drawings of them—seems to have stayed in his subconscious mind, even after he left the commonwealth to pursue his thirty-five-year career in the Northeast (1943 to 1978). The images floated about in his imagination, and they sometimes had curious dreamlike consequences. One of Lancaster's earliest articles was "Three Gothic Revival Houses at Lexington," a 1947 discussion of Loudoun, Ingelside, and Elley Villa. For one of his children's books, *The Periwinkle Steamboat*, he drew Creech Castle, the home of Mona Moss, who seems a bit like his old Lexington friend Miss Iva Dagley of Elley Villa. Creech Castle is an architectural omelet,

a stirring up of the ingredients of those three Gothic buildings of Lexington—the square overall form of Ingelside, the oriel window of Elley Villa resting over the door to Loudoun, the triple chimneys of Elley Villa and the sexton's cottage of the old Episcopal burying ground, and the Gothic umbrage that suggests both Loudoun and Elley Villa.[25]

Lancaster published two early articles, in 1948 and 1950, that dealt with the use of American architectural plan books in early central Kentucky and elsewhere—books such as those by A. J. Downing, which contained Elley Villa; Samuel Sloan's *Model Architect,* which contained Lyndhurst; and details from the work of others, such as Minard Lafever, whose suggestions for doorways and centerpieces abound in Ward Hall, at Diamond Point, and in Richmond's Rosehill. At the end of his life, Lancaster, like Palladio, produced *Quattro Libri dell'Archittetura,* or four architectural plan books of his own: *Architectural Edification, Architectural Exotica, Architectural Domestication,* and *Architectural Residuum.*[26] Although there are a few imaginative modern plans, for the most part, these offer historic residences adapted to the modern conveniences of kitchens and baths. Looking at them is a test of sorts, trying to identify their sources and analogues from drawings and photographs. One Barclay Square at first seems to be Federal Hopemont, the Hunt-Morgan House as drawn by Lancaster for *Ante Bellum Houses of the Bluegrass.*[27] Then there is Gothic Revival Inglewood, a name reminiscent of McMurtry's Ingelside; the imaginary building itself recalls the cottage of the old Episcopal cemetery.[28] Consider Lancaster's Orchard Cottage—nearly latent on the page are Classic Cottage, which once stood at the site of the Esplanade in Lexington; the Muldrow House from Woodford County; and Rose Hill on Lexington's North Limestone Street.[29] Lancaster had a photographic memory, but one that was capable of montage and protean re-creation. His photograph of Italianate Glengarry is suggestive of his own

Sunny Crest.[30] Greek Revival Bird Park reminds us of Lemon Hill.[31] Lancaster worked the puzzles over and over in his mind, as did Downing, Calvert Vaux, Lafever, Sloan, and Palladio. Lancaster's early visits to Kentucky houses and his photographs of them influenced him for years to come and played an important role in his creative life.

Although it apparently never occurred to Lancaster to prepare an album of his own architectural photographs for publication, he worked on several collections of recent and historic photographs. These three enterprises, all for Dover Publications, include his introductory essay for *Victorian Houses: A Treasury of Lesser Known Examples* (1973), with photographs by Edward V. Gillon; an extensive introductory essay and interpretive comments for *New York Interiors at the Turn of the Century* (1976), showing 131 photographs by Joseph Byron selected from the collection at the Museum of the City of New York; and the introduction and captions for 180 vintage views featured in *Nantucket in the Nineteenth Century* (1979). Lancaster's *Architecture of Historic Nantucket* makes extensive and exclusive use of antique images, but the textual treatment is developed in full scholarly form; thus the character of the book is quite different from the slender but charming Dover albums.[32]

Lancaster would perhaps be surprised, and amused, to learn that his own photographs were exhibited in the Central Library Gallery of his old hometown (16 April to 23 May 2004), the J. B. Speed Art Museum in Louisville (21 September 2004 to 2 January 2005), and the Preservation Institute: Nantucket (May 2005).[33] With slight variation, the present volume essentially preserves these three 2004–2005 Lancaster photographic exhibitions, focused on Kentucky structures. Anyone seeking further information on the sites depicted should consult Lancaster's own narratives about Lexington (*Vestiges of the Venerable City*), Fayette County (*Ante Bellum Houses of the Bluegrass*), and Kentucky (*Antebellum Architecture of Kentucky*).

We must remember that Clay Lancaster was not alone in his fascination with early Kentucky buildings during the 1930s. However, he came along at just the right time to give the process an extremely high level of expert description. Lancaster possessed the perfect scholarly mind to document and correctly describe key structures without reference to any extra-architectural historical events or personalities. He extended the work of Frank Dunn, Elizabeth Simpson, and others to a full, majestic sweep of Fayette County and then the entire state (and beyond this, to Old Brooklyn Heights and then Nantucket). With his ability to draw, analyze, research, and relate building features to original drawings, plan books, and other contemporary sources, he generated an architectural record of Kentucky that would be envied by any other state. His early photographs were merely the beginning of that process.

Notes

1. "Courthouse Fountain," donated by Lancaster's great-uncle, E. B. Ellis, in 1921, described in the *Sunday Herald-Leader* (which was the 75th Anniversary Edition of the *Lexington Leader*), 19 May 1963, A-67.

2. See James D. Birchfield, "Introduction," *A Bibliography of Clay Lancaster* (Lexington: University of Kentucky Libraries, 1992), vi–ix.

3. Clay Lancaster, "The Work of John McMurtry" (master's thesis, University of Kentucky, 1939).

4. Thomas Tileston Waterman, *The Early Architecture of North Carolina* (Chapel Hill: University of North Carolina Press, 1941), vi–vii.

5. Douglas C. McMurtrie, *American Imprints Inventory No. 5: Check List of Kentucky Imprints 1787–1810* (Louisville: Historical Records Survey, 1939).

6. Beverly W. Brannan and David Horvath, eds., *A Kentucky Album: Farm Security Administration Photographs 1935–1943* (Lexington: University Press of Kentucky, 1986).

7. Haden Kirkpatrick, "Reproduction of Loudoun House on Paper Plan: Architects End Survey Work, Drawings to Go to Library of Congress," *Lexington*

Herald-Leader, 16 June 1940. A recent example of how photographs generated by the HABS continue to be of interest today is in William Baldwin and V. Elizabeth Turk, *Mantelpieces of the Old South: Lost Architecture and Southern Culture* (Charleston: History Press, 2005).

8. C. Frank Dunn wrote numerous newspaper features on Lexington history and buildings. One, entitled "Mystery Houses," ran in the *Lexington Herald-Leader* from February to April 1941 and ended in a spirited contretemps over the location of the Mentelle School. See William H. Townsend and C. Frank Dunn, *The Boarding School of Mary Todd Lincoln: A Discussion as to Its Identification* (Lexington: privately printed, 1941). Of particular value are three Dunn articles: "435 Houses, Still Standing, Represent History from First Log Cabin," *Lexington Herald-Leader,* 4 January 1948; "Half a Hundred Distinguished Old Residences, Many Built by Pioneers, Still Stand in Fayette," *Lexington Herald-Leader,* 26 June 1949; and "Fayette County Has 275 Houses That Were Erected before 1825," *Lexington Herald-Leader,* 23 May 1954.

9. See Thomas D. Clark, "The Book Thieves of Lexington: A Reminiscence," *Kentucky Review* 5, no. 2 (winter 1984): 27–45; reprinted in *Register of the Kentucky Historical Society* 103, nos. 1 and 2 (winter–spring 2005): 47–66; significantly enlarged, the essay reappears as Chapter 20 in Clark's *My Century in History: Memoirs* (Lexington: University Press of Kentucky, 2006), 332–53; Charles R. Staples, *The History of Pioneer Lexington* (Lexington: Transylvania Press, 1939).

10. J. Winston Coleman authored two series of illustrated newspaper features for the *Lexington Herald-Leader* entitled "Historic Kentucky." The first ran from 10 October 1948 until 10 August 1952, and the second ran from 7 January 1962 until 22 August 1965. His book *Historic Kentucky* (Lexington: Henry Clay Press, 1968; reprint, 1973) was based on the newspaper features.

11. Robert C. May, "The Lexington Camera Club: 1936–1972," *Kentucky Review* 9, no. 2 (summer 1989): 3–47; reprinted as an exhibition catalog, *The Lexington Camera Club 1936–1972* (Lexington: University of Kentucky Art Museum, 1989).

12. For information about Colonel James Maurice Roche, see Frederick Jackson, "Upon His 80th Birthday, Jim Roche, That Magnetic Irishman, Challenges All Comers to a Foot Race, a Jump, or a Wrestle," *Lexington Leader,* 31 March 1938; "James M. Roche 82 Years Old: Historian Observes Birthday Informally," *Lexington Herald-Leader,* 31 March 1940; "End Comes to James M. Roche: Long Illness Fatal to Local Historian," *Lexington*

Herald, 8 May 1942; John Wilson Townsend, "Jim Roche, Raconteur," in *Three Kentucky Gentlemen of the Old Order* (Frankfort: Roberts Printing Co., 1946), 43–51.

13. Clay Lancaster, *Antebellum Architecture of Kentucky* (Lexington: University Press of Kentucky, 1991), x.

14. Related in a conversation with Bettye Lee Mastin, 16 July 2005.

15. Letter from Patrick A. Snadon, 6 October 2004.

16. Lancaster, "Introduction," *Antebellum Architecture of Kentucky,* 1.

17. Clay Lancaster, *Ante Bellum Houses of the Bluegrass* (Lexington: University of Kentucky Press, 1961), xiii.

18. "Current and Coming: Early Photography" [review of the Metropolitan Museum exhibition *The Dawn of Photography: French Daguerreotypes, 1839–1855*], *Antiques,* September 2003, 18.

19. Ibid.

20. The view of Gratz Park forms the endpapers for *Ante Bellum Houses of the Bluegrass;* the composite view of the row of West High Street houses is in Lancaster's *Vestiges of the Venerable City* (Lexington: Lexington-Fayette County Historic Commission, 1978), 145.

21. Berenice Abbott, *The World of Atget* (New York: Horizon, 1964), xi–xii.

22. For work by Frances Benjamin Johnston, see *Mammoth-Cave by Flashlight* (Washington, D.C.: Gibson Brothers, 1893); Henry Irving Brock, *Colonial Churches in Virginia* (Richmond: Dale Press, 1930); Waterman, *Early Architecture of North Carolina;* Frederick Doveton Nichols, *Early Architecture of Georgia* (Chapel Hill: University of North Carolina Press, 1957); and *The Hampton Album* (New York: Museum of Modern Art, 1966). For information about Johnston herself, see Pete Daniel and Raymond Smock, *Talent for Detail: The Photographs of Miss Frances Benjamin Johnston, 1889–1910* (New York: Harmony Books, 1974); Bettina Berch, *Woman behind the Lens: The Life and Work of Frances Benjamin Johnston, 1864–1952* (Charlottesville: University of Virginia Press, 2000); and Lamia Doumato, *Frances Benjamin Johnston, Architectural Photographer: A Bibliography* (Monticello, Ill.: Vance Bibliographies, 1990).

23. Quoted from Fritz Gruber, "Clarence John Laughlin: A Mystic of the Camera," *Photo-Prisma* (February 1960), translated by Dr. Eric Albrecht and cited in John H. Lawrence and Patricia Brady, eds., *Haunter of Ruins: The Photography of Clarence John Laughlin* (Boston: Little, Brown, 1997), 48. Note also several exhibitions: "Haunter of Ruins: The Photography of Clarence John Laughlin," Historic New Orleans Collection, 7 October 1997 to 21 March 1998; "Haunter of Ruins: Clarence John Laughlin,"

Morris Museum of Art, Augusta, Georgia, 3 December 1998 to 17 January 1999; "Land of Myth and Memory: Clarence John Laughlin and the Photographers of the South," High Museum of Art, Atlanta, 25 January to 9 August 2003.

24. Linda Butler, *Inner Light: The Shaker Legacy* (New York: Alfred A. Knopf, 1985).

25. Clay Lancaster, "Three Gothic Revival Houses at Lexington," *Journal of the Society of Architectural Historians* 6 (1947): 13–21. For Creech Castle, see *The Flight of the Periwinkle* (Salvisa, Ky.: Warwick Publications, 1987), 32–38; this is a reprint of Lancaster's *The Periwinkle Steamboat* (New York: Viking, 1961). The tinted original drawing for Creech Castle still hangs in Clay Lancaster's bedroom at Warwick.

26. Clay Lancaster, *Architectural Edification: An Album of 24 Original Designs in Traditional American Styles* (Salvisa, Ky.: Warwick Publications, 1996), *Architectural Exotica: An Album of 24 Original Designs in Mannerist, Romantic, and Fantasy Styles* (Salvisa, Ky.: Warwick Publications, 1997), *Architectural Domestication: An Album of 24 Original Designs in the Federal and Greek Revival Styles* (Salvisa, Ky.: Warwick Publications, 1999), and *Architectural Residuum: An Album of 24 Original Designs in 17th to 20th Century Styles* (Salvisa, Ky.: Warwick Publications, 2000).

27. See Hopemont in *Ante Bellum Houses of the Bluegrass,* 48, and One Barclay Square in *Architectural Residuum,* 49.

28. See Inglewood in *Architectural Exotica,* 83; cf. the sexton's cottage in Clay Lancaster, *Back Streets and Pine Trees* (Lexington: Bur Press, 1956), 107.

29. Orchard Cottage appears in *Architectural Edification,* 37; cf. Rose Hill in *Ante Bellum Houses,* 63; Classic Cottage in *Ante Bellum Houses,* 77; the Muldrow House, or Mount Airy, in *Antebellum Architecture of Kentucky,* 161; and White Cottage in *Ante Bellum Houses,* 75–76.

30. Sunny Crest is in *Architectural Edification,* 81.

31. Bird Park is in *Architectural Domestication,* 89.

32. Clay Lancaster, *Architecture of Historic Nantucket* (New York: McGraw-Hill, 1972).

33. On the Lexington exhibition, see Diane Heilenman, "Clay Lancaster: Preservationist Set Tone for Movement with Kentucky Roots That Stretched Far," *Louisville Courier-Journal,* 4 April 2005, I-1, I-3, and Scott Sloan, "Photos Document Antebellum Legacy," *Lexington Herald-Leader,* 19 April 2004, B3; on the Speed Museum exhibition, see Charles Thompson, "Lost Glories," *Kentucky Humanities,* October, 22–25; on the Nantucket exhibition, see "Photographic Memory: Clay Lancaster Exhibit Headlines Island's Annual Historic Preservation Week," *Inquirer and Mirror,* 5 May 2005, 1C, 11C.

PHOTOGRAPHS

Clay Lancaster, New York, 1946

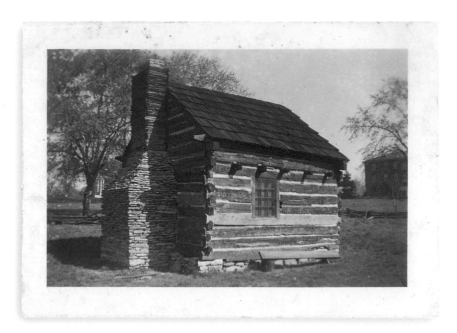

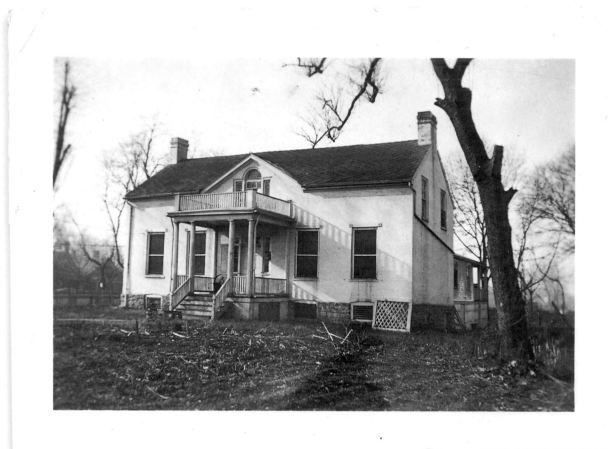

Pennsylvanian Robert Patterson arrived in 1779 from Harrodsburg to help settle what would become Lexington. He built a log cabin that now stands on the Transylvania University campus. He later built a stone residence; it acquired this trim brick front with Palladian window circa 1815, after Patterson had moved to Dayton, Ohio. The Patterson House came down when a large parking lot was built for the Civic Center in 1976.

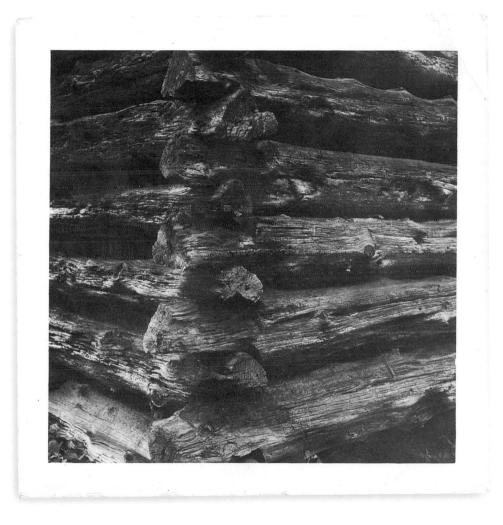

Notched logs of a dependency of the Joel DuPuy House in Woodford County, photographed in 1964.

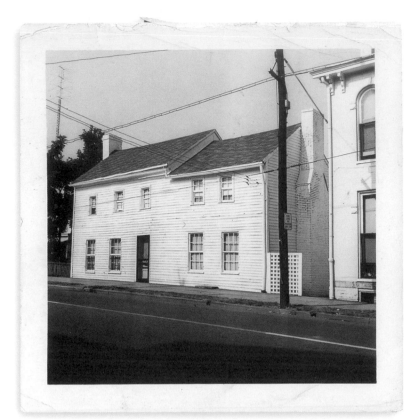

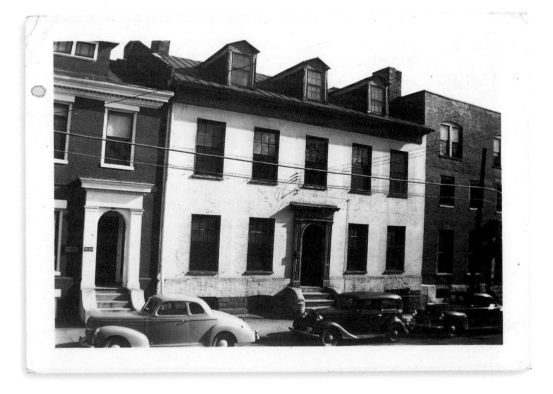

Controversial buildings from the urban renewal period of the 1970s *(above and facing page)*. The log and clapboard Adam Rankin House, the oldest house in Lexington, was saved when it was moved from 215 West High Street to nearby 317 Mill Street. The brick buildings farther east, just beyond Upper Street, were razed for parking.

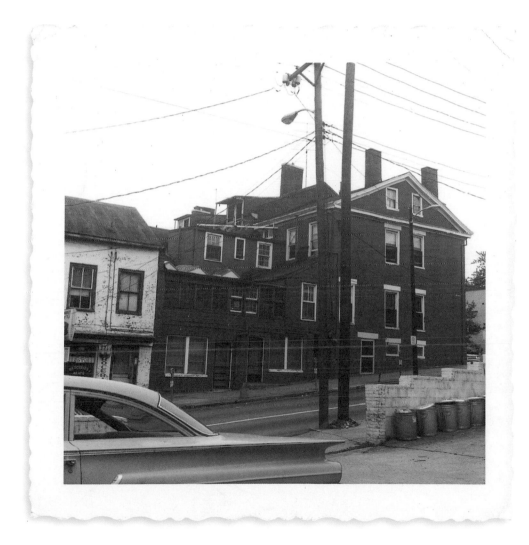

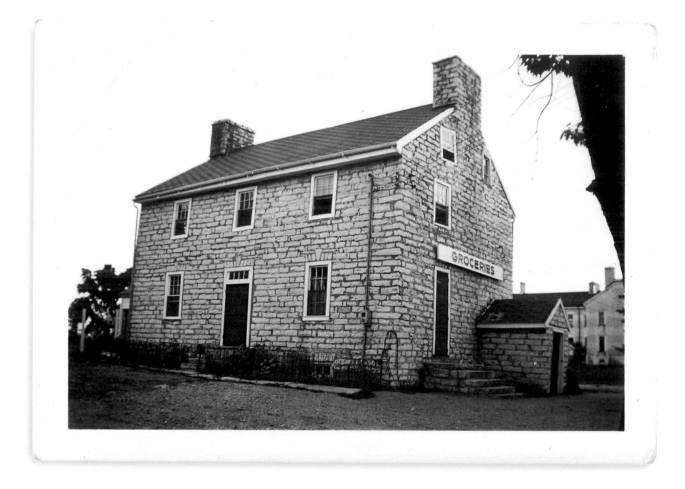

An 1809 Shaker building, the first Centre Family House at Pleasant Hill, was used as a grocery store in the 1940s.

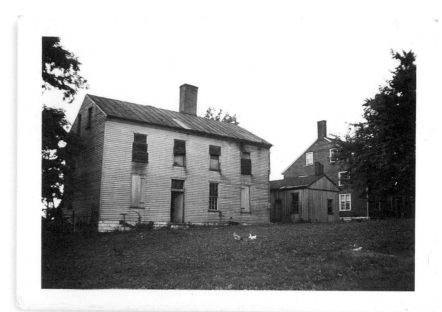

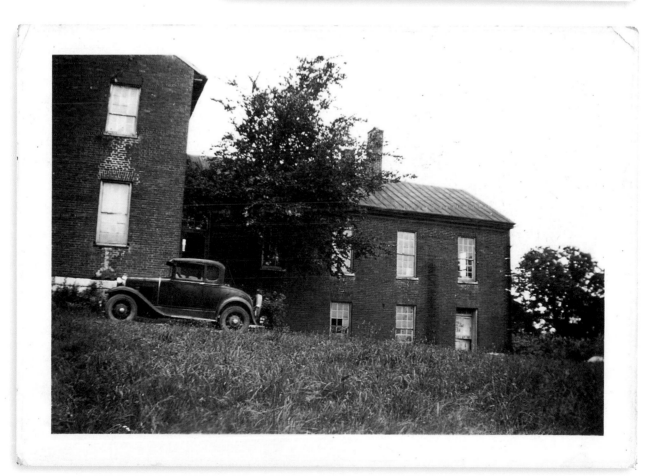

The Shaker Village of Pleasant Hill, in Mercer County, was largely constructed at the beginning of the nineteenth century. Although there were some losses, many of the buildings survived, and after restoration in the mid-twentieth century, the village was opened as a museum in 1968. These two images, made on 17 July 1940, show an unrestored wash house and preserve house and the south-side rear wing of the 1831 North Family House, which was lost in 1946.

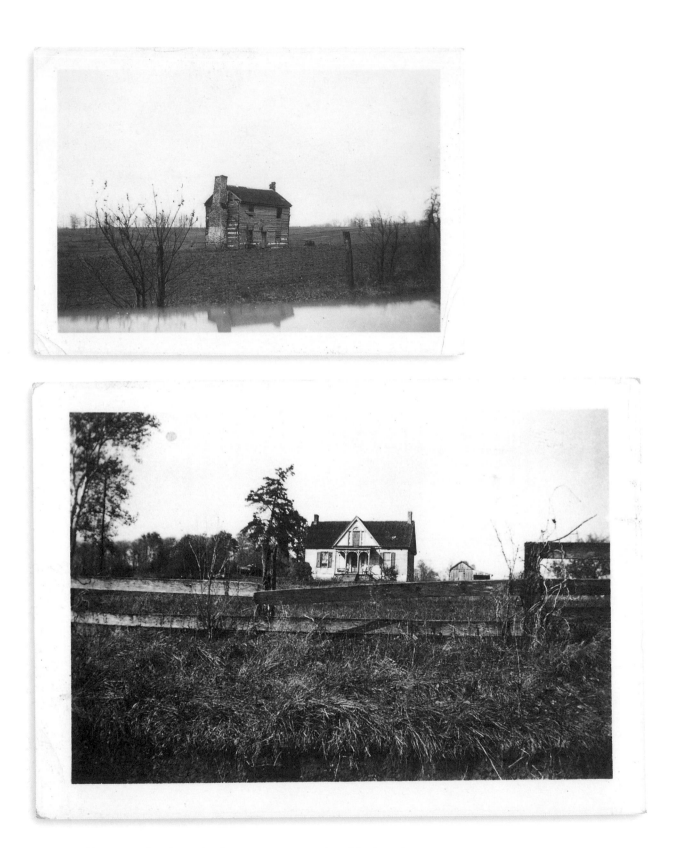

Two rural houses—a handsome log house as it appeared on 30 November 1940, and a Victorian frame cottage in Mason County, photographed 25 October 1940.

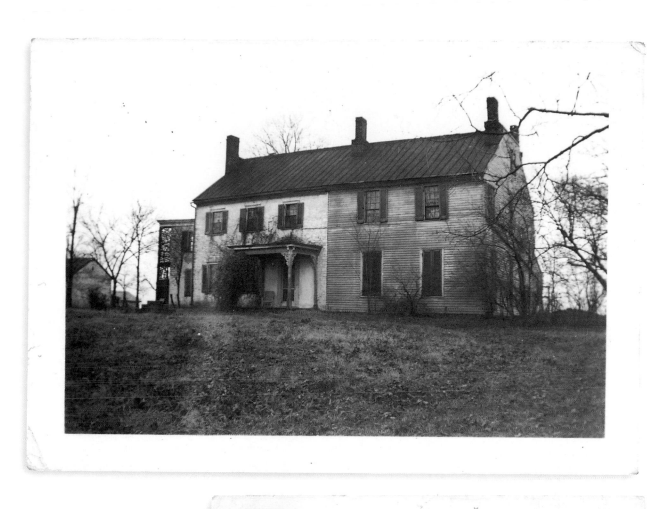

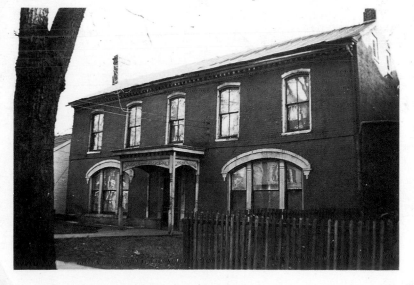

Two examples of architectural accretion. At Sumner's Forest on Shannon's Run Road in Woodford County, Dr. Joseph Humphreys ordered the frame addition at the right (photographed 27 December 1940) to house his extensive library and collection of portraits and busts. His grounds were kept by an English gardener. The Federal-era Nathaniel G. S. Hart House on North Limestone Street in Lexington displays Victorian arched windows and an Eastlake portico that have since been thoughtfully removed.

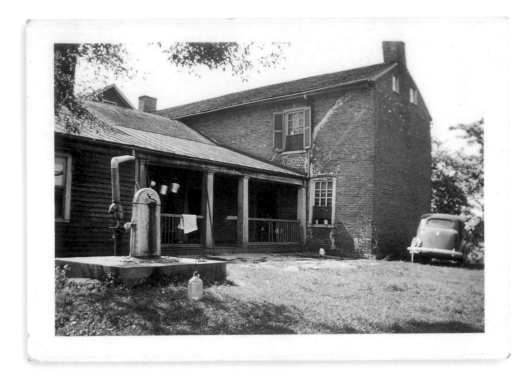

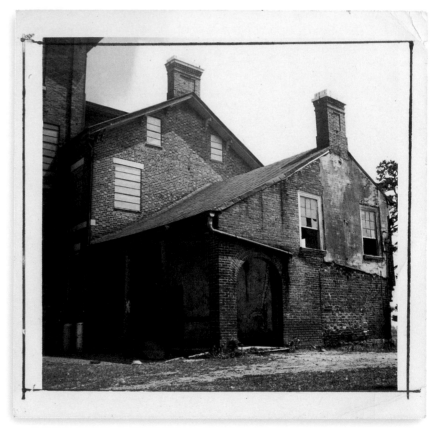

The oldest brick house in Madison County was photographed in September 1940. The other photograph, taken on 8 May 1969, is a side and rear view of the eighteenth-century Clermont (1798–1799) near Richmond, the house of General Green Clay. It was incorporated into White Hall, the home of his son, General Cassius M. Clay.

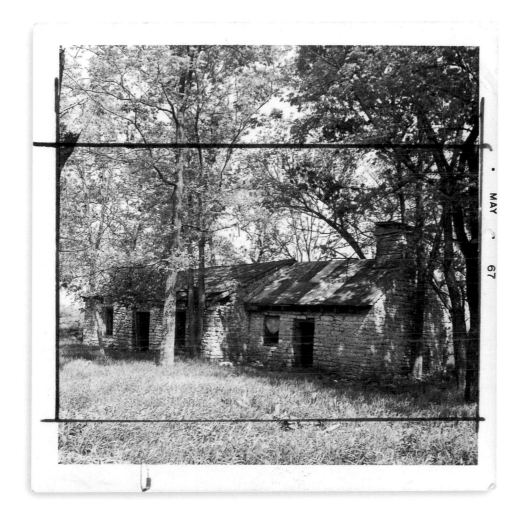

MAY 67

Among the early stone buildings of Kentucky is the slave quarters at White Hall, home of emancipationist Cassius Clay in Madison County. The larger section at the far left was added to the right section, which probably served as a kitchen. Clay Lancaster drew the crop marks when he used the image as an example of pioneer stone construction.

21

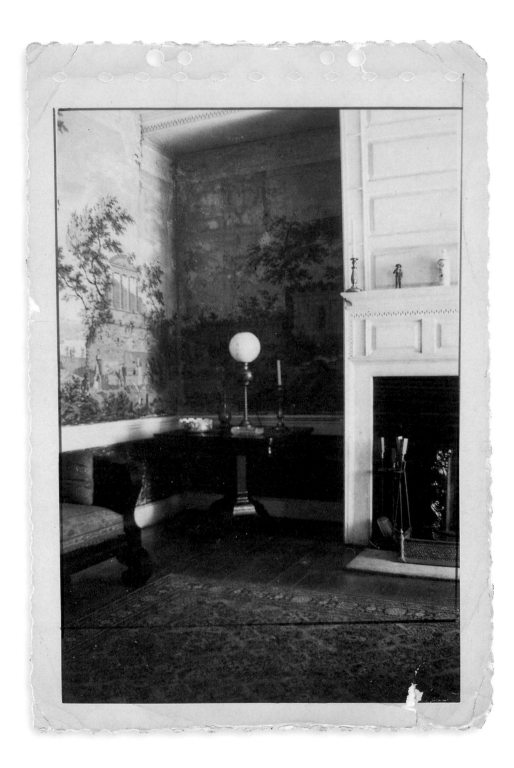

Late Empire furniture was present in the drawing room of Hurricane Hall when this photograph was made. The wallpaper, in the Castello d'Oro pattern, was hung to celebrate the 1817 wedding of Jane Quarles and William Z. Thompson; cabinets beside the paneled mantel were removed to give greater prominence to this new decoration. Built in the late eighteenth century for David Laughed of Virginia and located on Georgetown Road in Fayette County, Hurricane Hall has been compared to General Green Clay's Clermont in Madison County and Steel's Run, a house west of Elkchester Road in Fayette County.

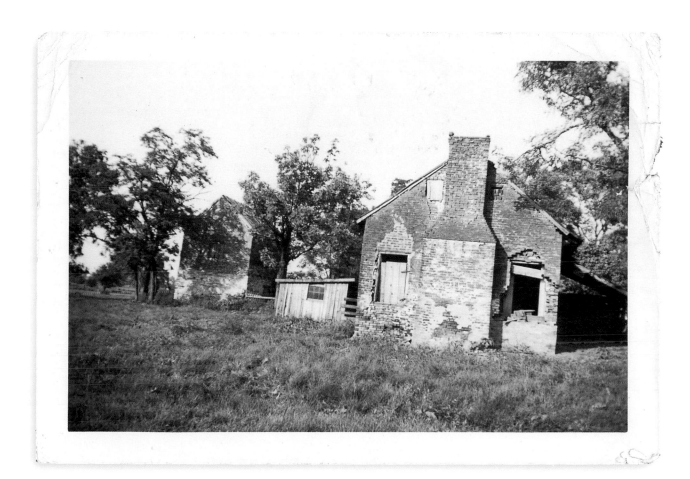

Various dependencies, including slave cabins, once stood to the west of Hurricane Hall. This grouping included a schoolhouse and a large smokehouse.

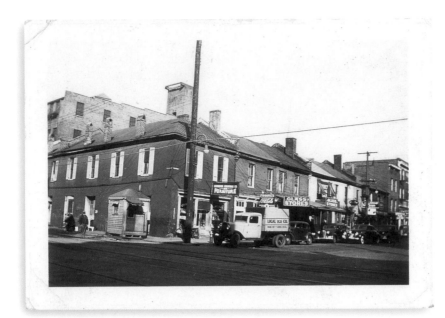

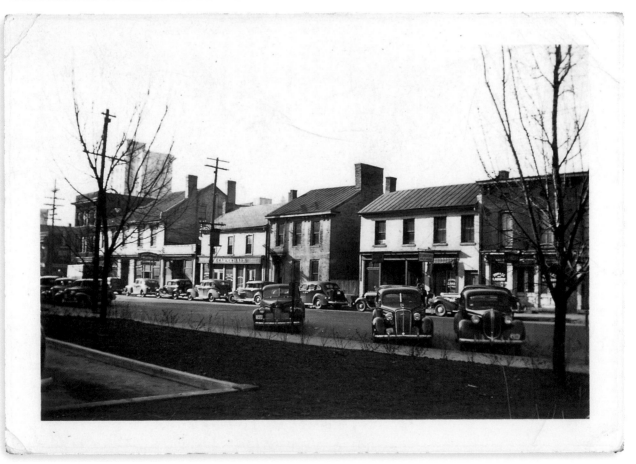

Two street scenes of Lexington. One shows the block of Main Street that was razed for Triangle Park in the 1970s. The other shows the block of North Limestone Street opposite the Barr Street Federal Building.

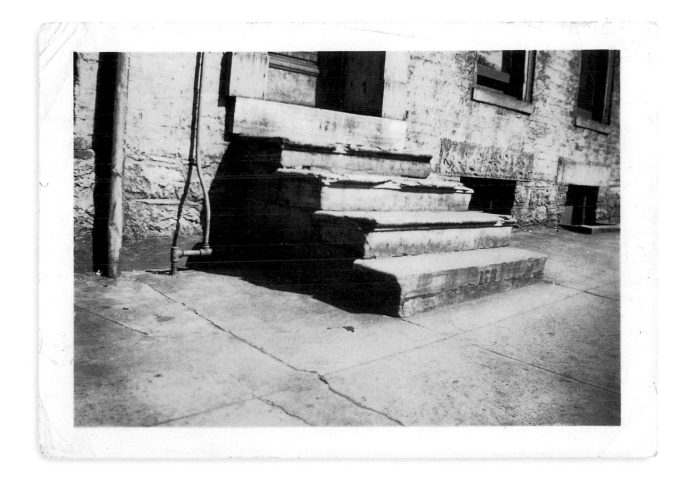

In the nineteenth century, fine steps were made of stone, not brick. Those of the Federal era, as illustrated by the top three treads in this photo, were carved to display a nosing at the front and side, as opposed to the simpler, squared steps of the later Greek Revival. (The latter, however, were often bush-hammered to give the stone a regular, ornamental pattern of parallel lines.) These early stone steps at 173 North Limestone Street in Lexington, between Church and Second, were photographed 29 April 1941.

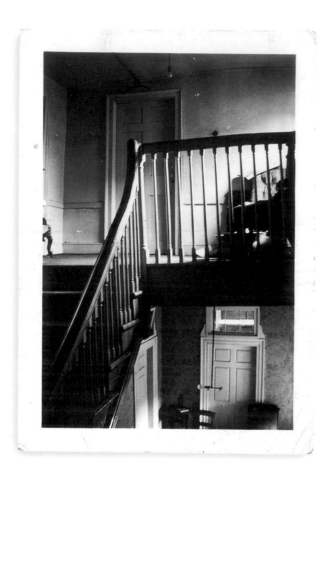

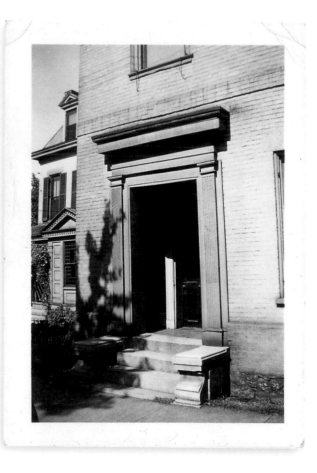

26 The doorway of the house of Miss Laura Clay (daughter of Cassius M. Clay), as seen on 15 September 1941, and the stairway to the third floor, pictured on 12 July of the same year. The house was built in the late eighteenth century by Colonel Thomas Hart; his daughter Lucretia married Henry Clay there in 1799. Located on North Mill Street in Lexington, it was more generally known as the John Bradford House, after Kentucky's first printer, who lived there from 1806 until his death in 1830. Demolition of the Bradford House for a parking lot by R. W. Welch in March 1955 sparked a furor, resulting in the establishment of the Blue Grass Trust for Historic Preservation.

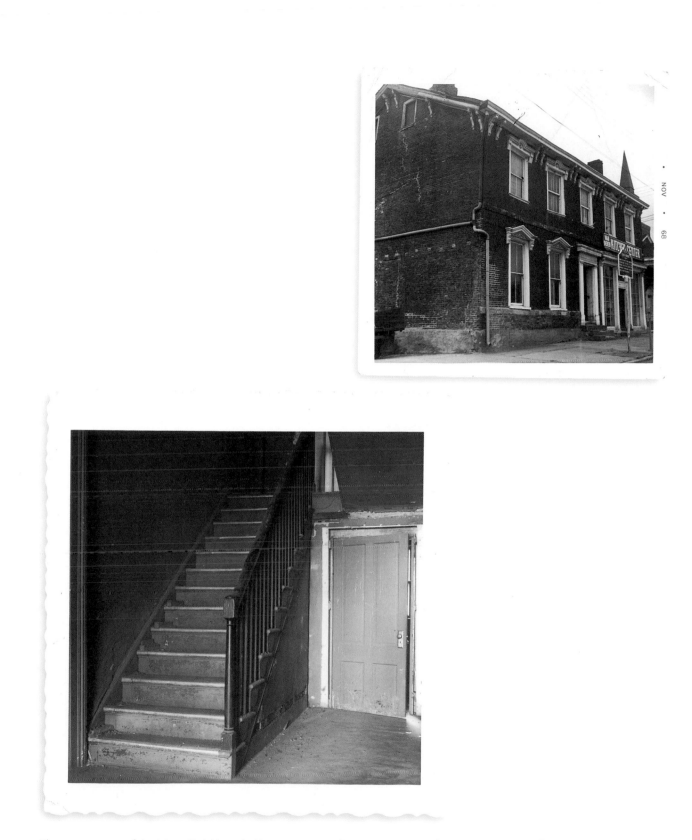

These two views of the Mary Todd Lincoln House, on Main Street in Lexington, date to its service as the Van Deren Kitchen Center. Although best known for its association with the Robert Smith Todd family, the structure was originally William Palmateer's inn, the Sign of the Green Tree.

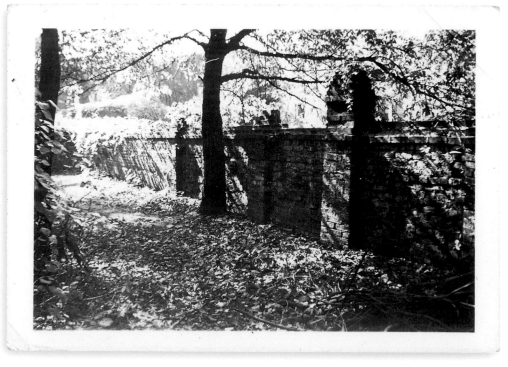

28 Fences in Lexington—downscale and upscale. On Euclid Avenue, behind a
house fronting Upper Street, is a vernacular picket fence. Along the byway near
Gratz Park is a handsome old masonry garden wall.

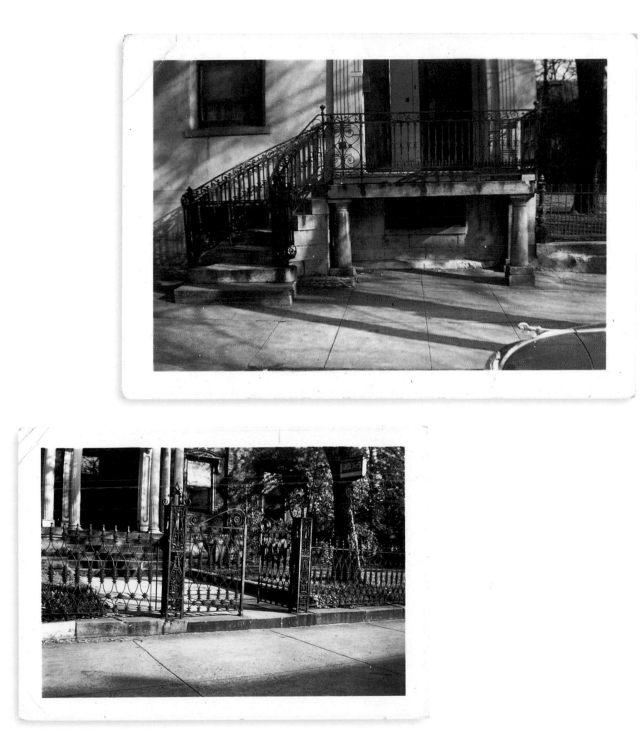

In May 1948 Clay Lancaster published an article in *Antiques* titled "The Early Ironwork of Central Kentucky and Its Role in the Architectural Development." Here are two examples of fine ironwork in Lexington: a stair rail at the James Fishback House, 176 North Broadway (the stonework is sometimes attributed to sculptor Joel T. Hart), and the fence at the house of Matthew Kennedy, Kentucky's first architect, at 216 North Limestone.

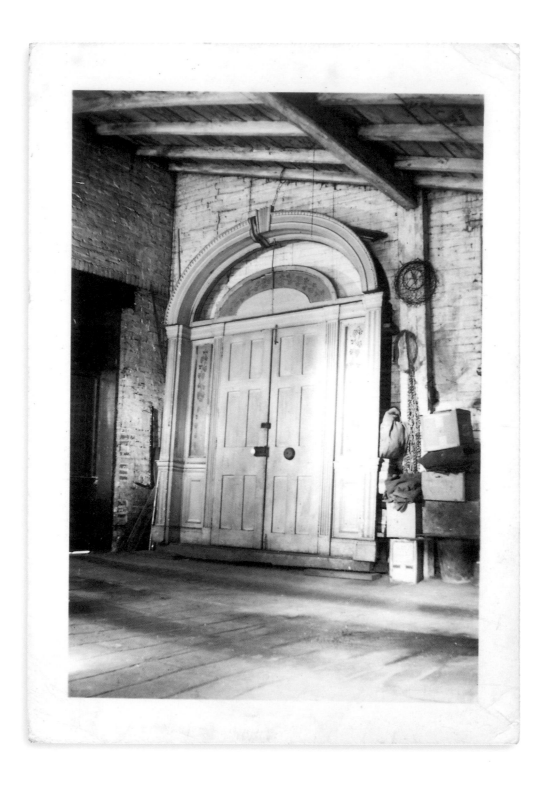

30 | This Federal-period doorway was salvaged from the John B. Thompson Jr. (later Goddard) residence in Harrodsburg when the house was torn down to make way for a public school. The frontispiece is shown here on 29 August 1943 at the Bodley-Bullock House garage in Gratz Park in Lexington. The rear door of the house was used at the Reverend James McChord's residence, Llangollen, at 450 North Limestone Street in Lexington.

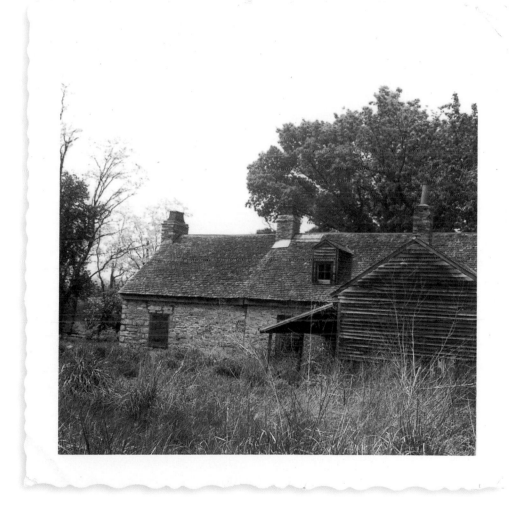

An early stone cottage with a frame addition.

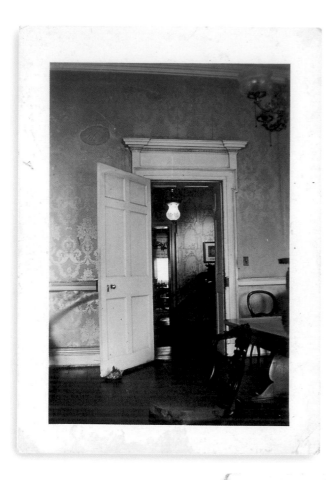

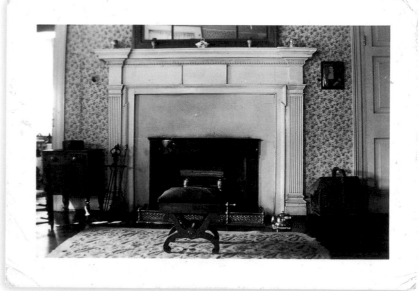

Liberty Hall in Frankfort (1796–1804) was supposed to be built from drawings provided by Thomas Jefferson, a friend of Kentucky senator John Brown. Jefferson's proposal arrived too late, however, and Brown had already resorted to a plan similar to Annapolis's Georgian Hammond-Harwood House. Clay Lancaster photographed the interior in November 1941, revealing Federal-era woodwork but Victorian light fixtures and furnishings.

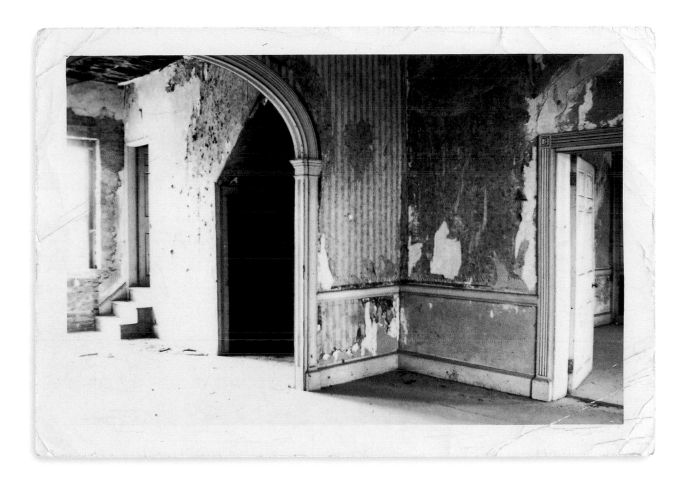

Poplar Grove was built circa 1810 near Parker's Mill Road in Fayette County. It has a central hallway, with two rooms on each side on the first floor and two rooms above. Long uninhabited, the building retained its original fine woodwork. The front of the house presents a dual-leaf doorway with leaded sidelights, surmounted by a leaded fanlight; the pattern of the leading relates to the designs at Hopemont and Plancentia. This view, from near the entrance, shows the central arch, the stair at the rear, and a doorway to a chamber at the right that contains presses on each side of the chimney.

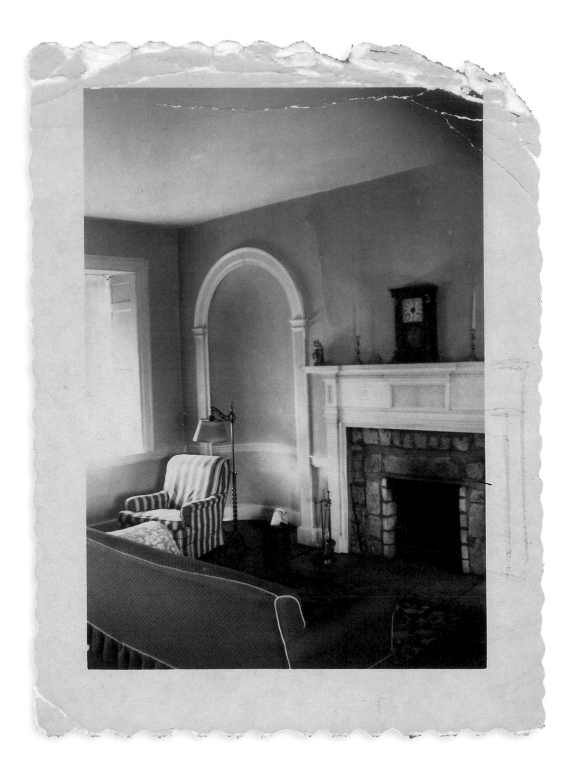

34 The Charles Grimes House of 1813, situated above Boone Creek on Grimes Mill Road, is described by Clay Lancaster as the "finest stone house in Fayette County" (and also its last notable one until Botherum in 1851). "In the parlor off the transverse stairhall," he wrote in 1961, "the fireplace is flanked by shallow niches enframed by an archivolt springing from reeded pilasters, matching those of the mantel." The Grimes House is contemporary with the Morton House, Rose Hill, Hopemont, and the Pope Villa.

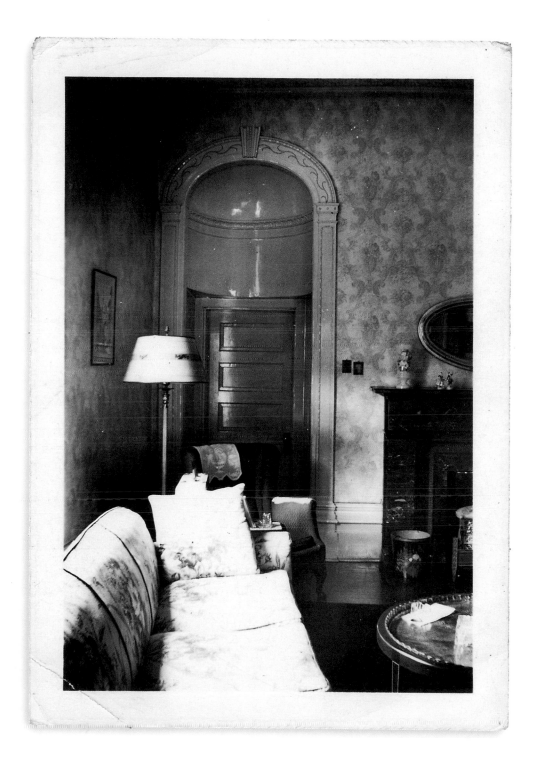

When looking through a group of plans for Virginia houses at the Library of Congress, Clay Lancaster found Benjamin Henry Latrobe's drawings for a Lexington house he recognized at once as the John Pope Villa, 326 Grosvenor Avenue. In the European manner, Latrobe placed the formal rooms on the second floor. Seen here is a statuary niche that has been converted into an apartment doorway, beside a classical black marble mantel. The room, drawn as a parlor on Latrobe's plan, has one rounded, apsidal end that adjoins the rounded end of the adjacent dining room.

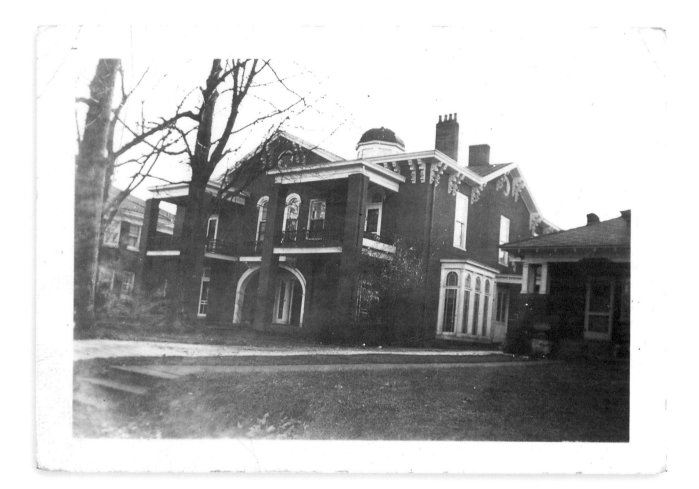

36 | The restrained lines of the original Pope Villa, constructed in 1811–1814, were greatly altered by later owners who added gables, brackets, porches, a cupola, iron window hood moldings, and an ell. Later, a street was laid through the front lawn, and the grounds were subdivided. The interior was modified as well, including the discarding of the original stairway; ultimately, the space was partitioned to make small apartments. Gutted by a fire in 1987, the building was acquired by the Blue Grass Trust for Historic Preservation and has been the subject of ongoing academic study and careful restoration. This photograph was taken on 26 December 1940.

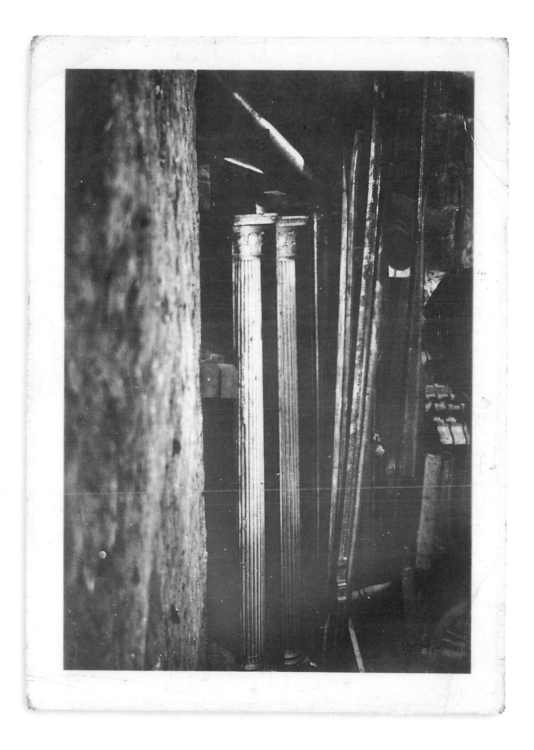

A view of John Wyant's basement at 325 Transylvania Park on 11 July 1942 reveals original interior architectural elements from the Pope Villa. From the remaining stair components, Clay Lancaster was able to determine that the Pope Villa stairway had been reversed to accommodate Senator Pope, who had lost his right arm in a farm accident. Original interior ornamental columns were also among this trove, which has since vanished.

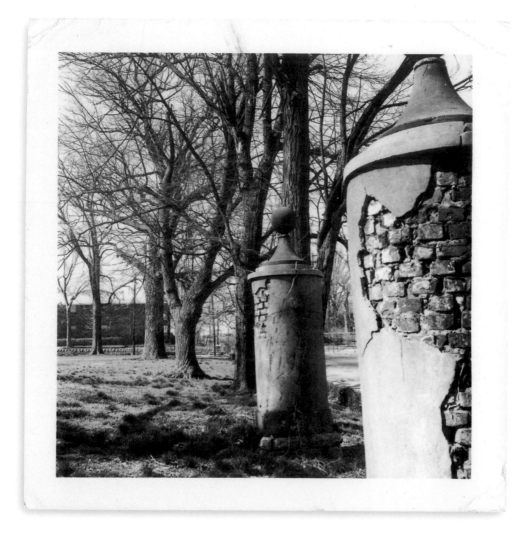

Above and facing page. Both home and office are suggested by these photographs of Englishman William Morton's gateposts (still near his house in Duncan Park) on North Limestone Street in Lexington and his commercial building at Water and Upper Streets, today Joe Rosenberg Jewelers.

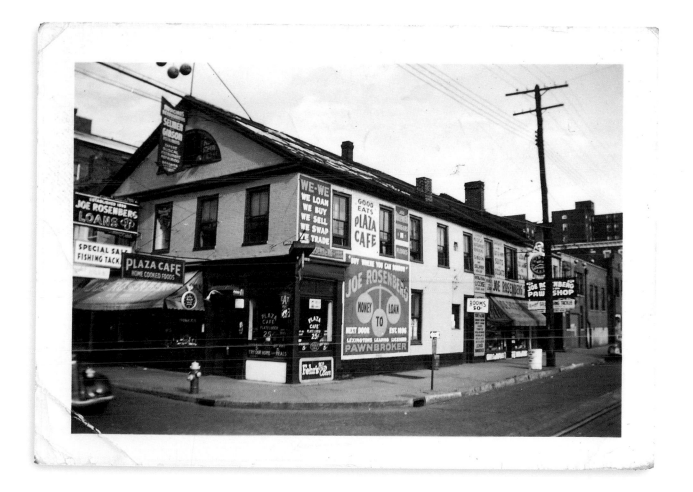

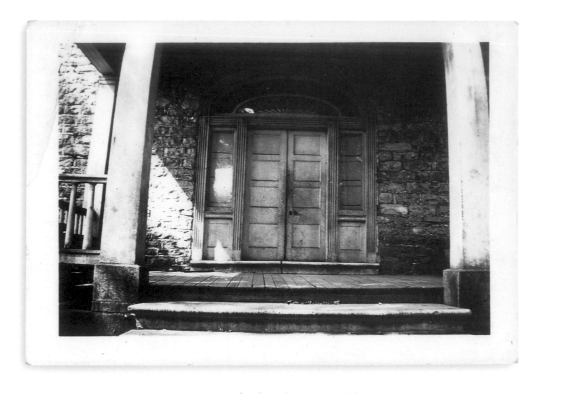

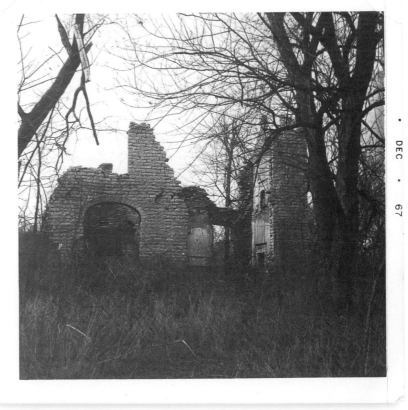

DEC • 67

This finely carved doorway of Tempest & Sunshine, a circa 1814 Federal-era stone residence in Franklin County, was photographed in September 1939. It was built for Colonel John Smith, who sold the property in 1831. The new owner moved the stone steps forward and added a two-story porch. Tempest & Sunshine burned in 1961.

The garden at Colonel John Smith's Tempest & Sunshine, with a wooden gate and a surviving set of stone carriage mounting steps.

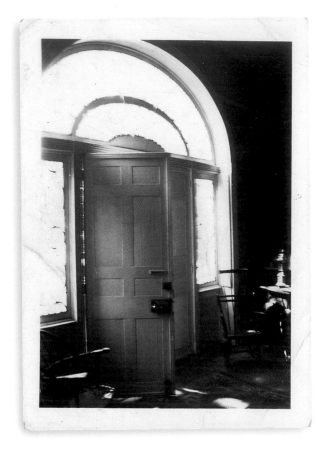

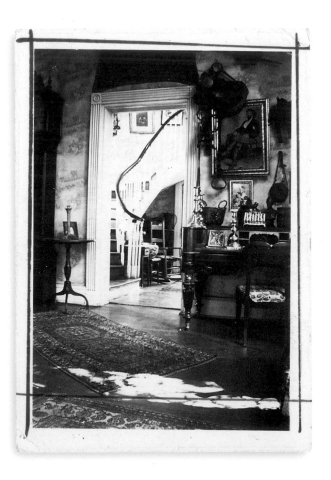

The paneled door and leaded fanlight of Hopemont, the John Wesley Hunt House (circa 1814), are viewed from within. Hopemont's curving stair is seen from the entrance. Also known as the Hunt-Morgan House, Hopemont is located on North Mill Street in Lexington.

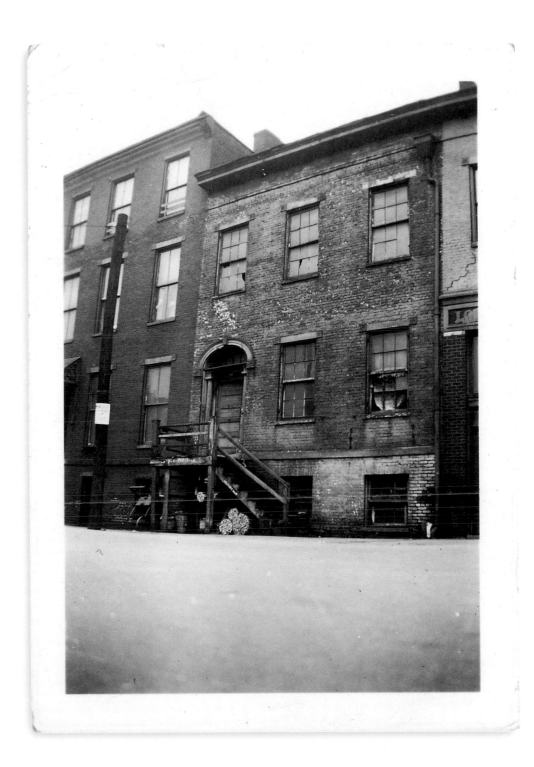

This structure on West Walnut, near First Street, in Louisville is a two-story Federal-era townhouse on a raised basement. An arch with voussoir defines a fan over the doorway. There is a stringer above the basement and a belt course near the roofline. The stringer has been cropped by a later commercial front at ground level, but the belt course continues across the original fabric.

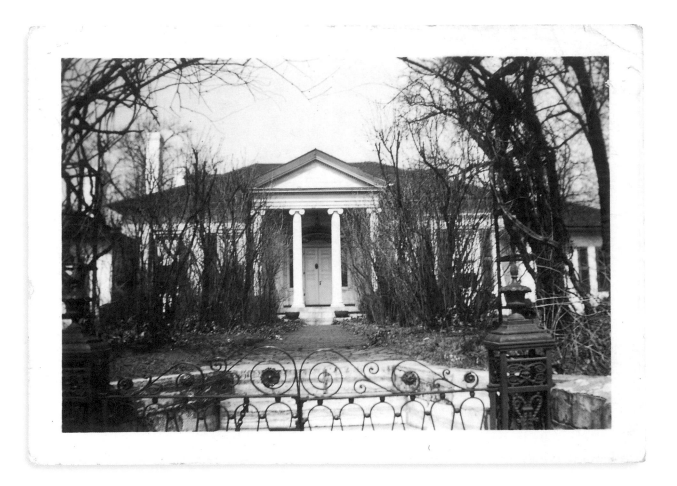

Rose Hill, the John Brand House on North Limestone Street in Lexington, was built circa 1812. Its portico was an accretion of the Greek Revival era. Clay Lancaster praised the house's "excellence of proportions, good disposition of parts, and fine details." It is also notable for the survival of its early brick dependencies.

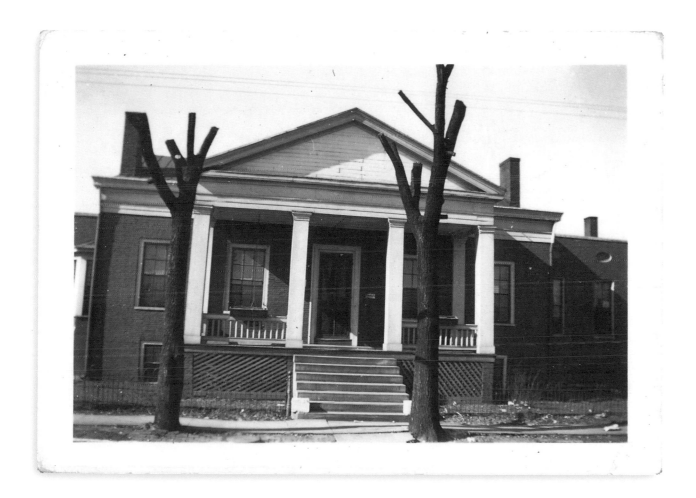

Major William S. Dallam, a Maryland capitalist, built this raised cottage, now 505 South Mill Street, Lexington, in 1813 and sold it in 1815 to Luther Stephens and Hallett M. Winslow, builders and sons-in-law of pioneer John Maxwell. The flankers and the portico are later additions. The family of Major Dallam's wife, Lucretia Meredith, lived at Winton; Dallam died in Gratz Park at the home of his son-in-law, Dr. Robert Peter. Major Dallam was living at the villa of Senator John Pope on 4 July 1819, where he entertained President James Monroe, Governor Isaac Shelby, General Andrew Jackson, and Colonel Richard M. Johnson.

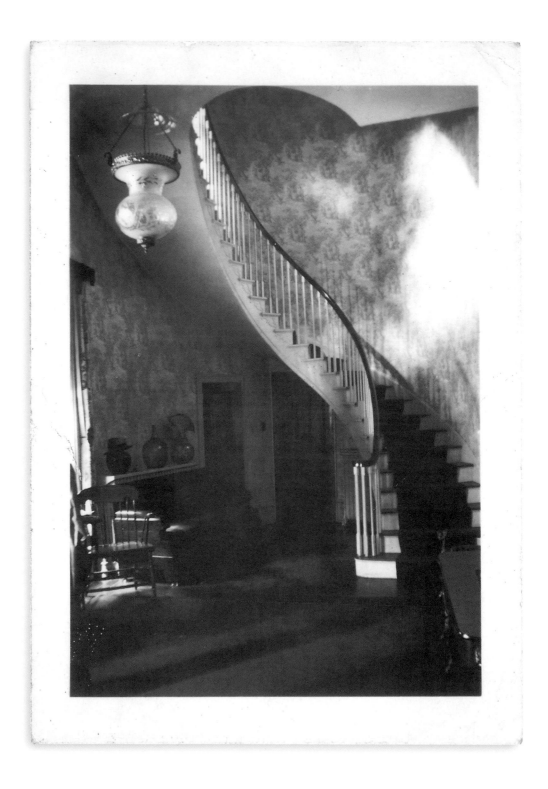

What is called the Bodley-Bullock House today, located at 200 Market Street in Gratz Park in Lexington, was built by Thomas Hart Pindell circa 1814. "The outstanding feature of the house," wrote Lancaster, "is the elliptical staircase connecting the three floor levels. The upward sweep is graceful and the treatment of details is restrained and delicate." This photograph was made on 28 August 1943.

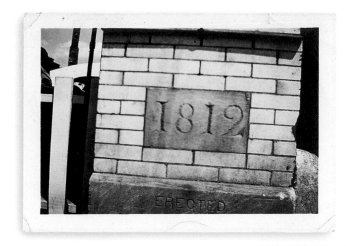

Here are two illustrations of dated architectural elements. The cornerstone block dated 1812 was once seen in the parapet of the Matthias Shryock House, north of the present opera house on North Broadway in Lexington; it was salvaged and worked into the masonry of the Mammoth Garage, 333 East Main Street, opposite Rose Street (demolished when Rose was extended to Elm Tree Lane). Builder Matthias Shryock was the father of Gideon Shryock, a student of William Strickland and the architect of the third state capitol and Morrison Hall at Transylvania University. Matthias's other son, Cincinnatus, was also a prominent Kentucky architect. The downspout, dated 1833, comes from the Yent House, which stood at 509 West High Street.

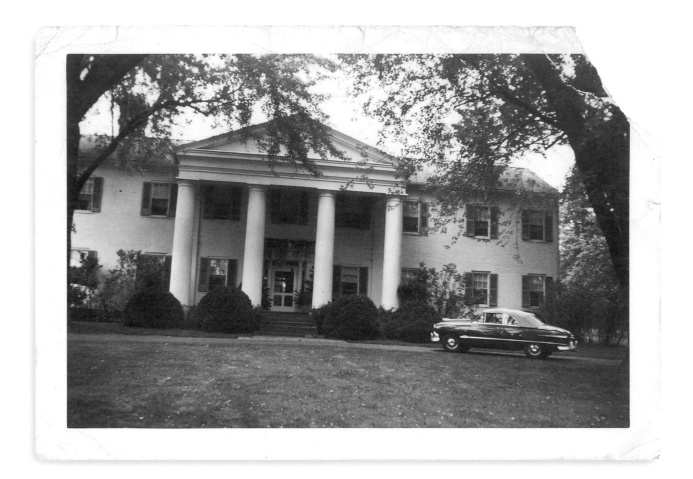

Two doomed Fayette County houses *(above and facing page)*. Mount Brilliant (circa 1790 with a later Greek Revival portico), seat of the Russell, Haggin, and Molloy families, once stood on Russell Cave Road. At one time it boasted the important private library of Colonel Louis Haggin, as well as fine formal gardens. It was wrecked on 21–22 November 2002.

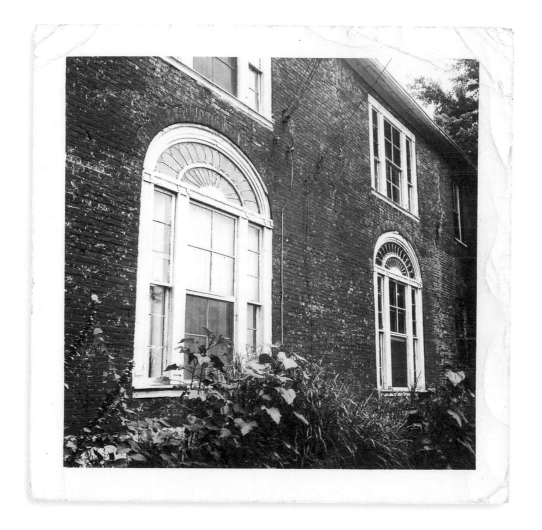

Plancentia, built for the enterprising Lewis Sanders, was sold uncompleted to Colonel James Morrison in 1815. The arched lunettes of the south windows are identical to the fan doorway at Hopemont, the Hunt-Morgan House. This Federal-era building on Georgetown Road, which once included a domed oval room measuring 26 by 30 feet and two octagonal rooms, was razed by Cutter Homes in 2002.

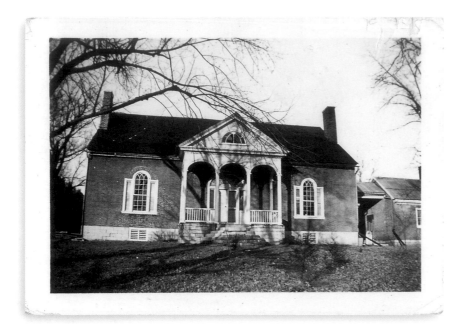

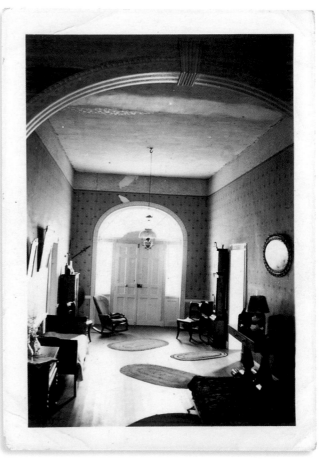

Mount Airy, the Colonel Andrew Muldrow House, circa 1815–1820, once stood in Woodford County. The entry hall with its early furnishings is shown on 10 February 1941. Mount Airy burned in 1945.

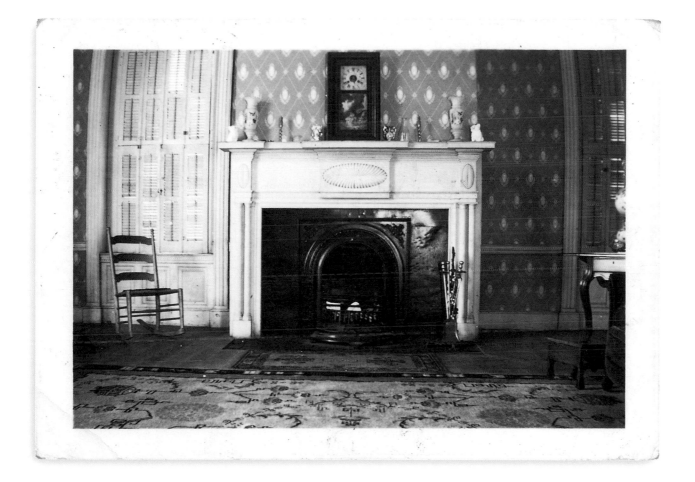

The parlor mantel of Mount Airy was also photographed 10 February 1941. The fireplace has been modified to burn coal.

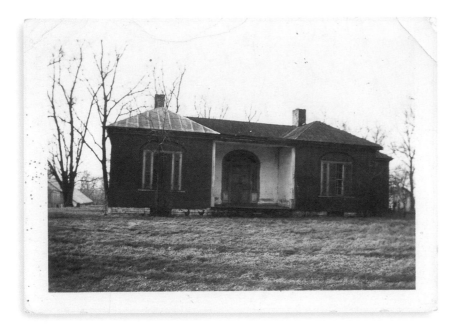

Above and facing page. The Jackoniah Singleton House in Jessamine County was built by an ancestor of Clay Lancaster between 1816 and 1820. Shown are the carriage side, with recessed portico and dual-leaf doorway with elliptical leaded fanlight; the garden side; a parlor with Federal mantel and grained door; and the dining room. The house is an analogue to the Levi Gist House, which once faced West Maxwell Street at the southeast corner with Mill in Lexington.

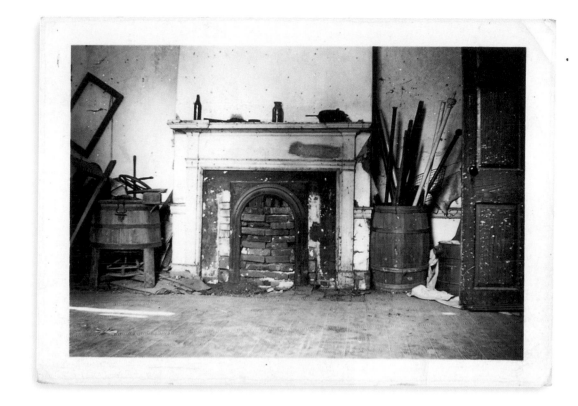

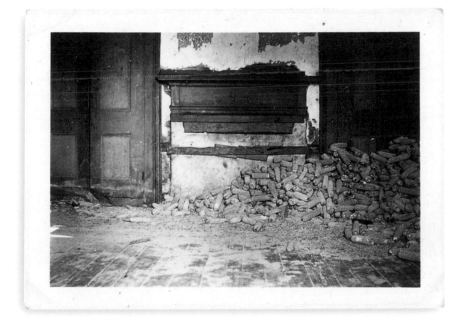

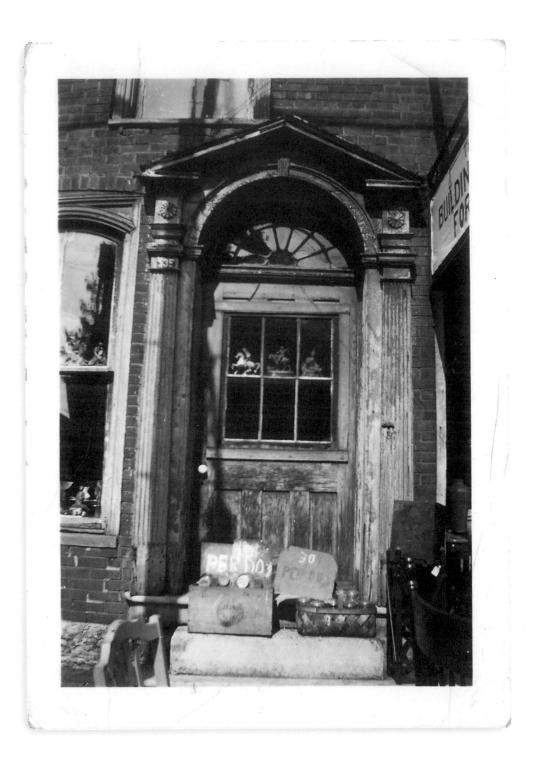

This Federal-style doorway once stood at Smiley's used furniture store at 535 West Short Street in Lexington. Shown here in August 1949, it had previously been removed from Coolavin, the Sixth Street residence of Judge Thomas Hickey. Coolavin was probably erected before 1820 for James January. Clay Lancaster relates the door to the office entrance at Hopemont and the doors of the original Transylvania building. After the Civil War, Coolavin was called Locust Grove.

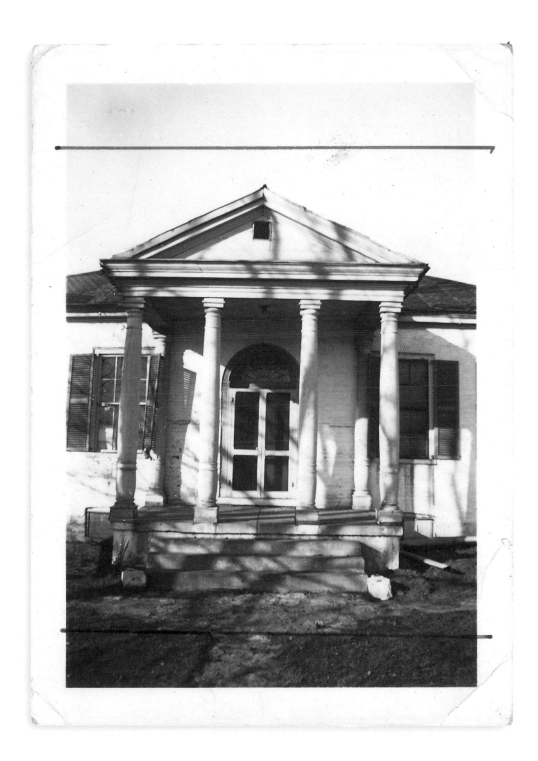

Lewis Manor, called Kilmore after 1915, was built for Colonel Thomas Lewis, father-in-law of General Green Clay. Erected circa 1800, Lewis Manor, on what is now Alexandria Drive in Lexington, displayed similarities in massing with the later-built Coolavin.

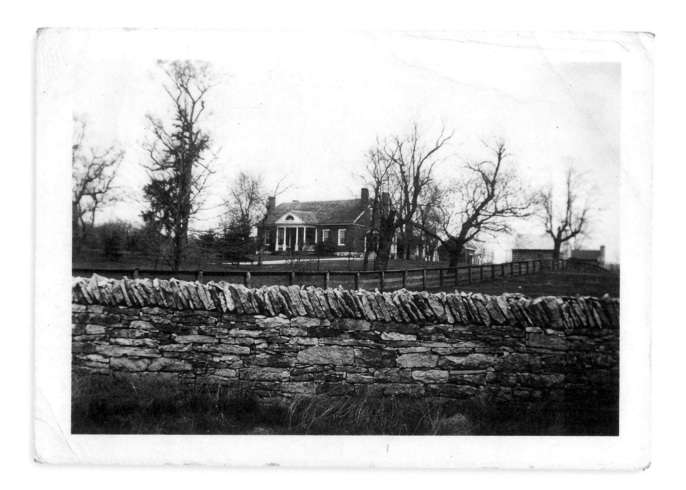

Seen beyond a dry stone wall, the Cleveland-Rogers House (circa 1820) on Old Richmond Road in Fayette County is a refined example of early Kentucky architecture. There are benches on the portico, a delicate fanlight in the tympanum, and beautifully reeded woodwork within. The Cleveland-Rogers House was once the home of Sarah Blanding, dean of women at the University of Kentucky and later president of Vassar College.

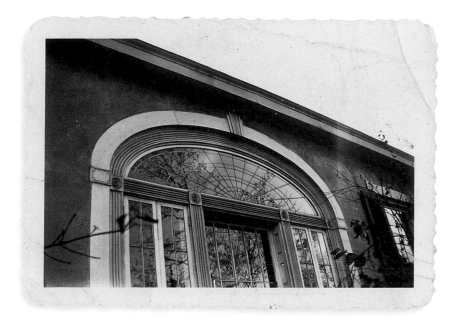

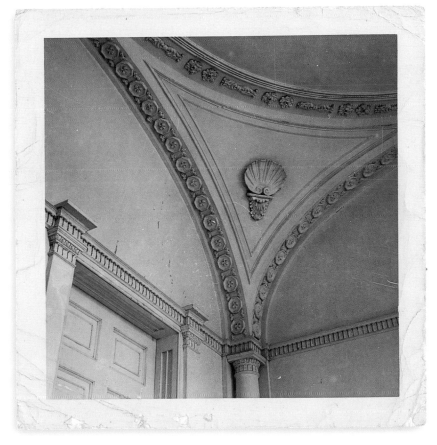

Elmwood Hall, in Ludlow, was built circa 1820 for Thomas Carneal, based on his own plans. Its fanlighted doorway, facing the Ohio River, may be the largest in America, and the ornamental plasterwork of its entrance hall is of extraordinary splendor. William Bullock, an Englishman who purchased the home and approximately a thousand acres in 1827, proposed but failed to establish an ideal community on the site. In 1831 Bullock sold the house and grounds to Israel Ludlow, whose father had laid out the city of Cincinnati.

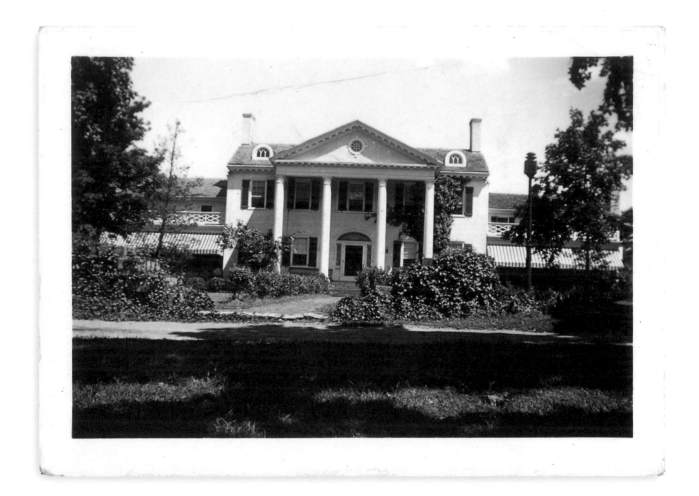

Cave Hill or Cave Place, once called Clingendaal, was built in 1821 by David Bryan. Porches were added after 1834, and in 1916 a colossal portico was placed at the front, dormers were added, and the wings were extended. During a restoration of the executive mansion in Frankfort, Cave Hill served as the residence of Governor John Y. Brown Jr. and First Lady Phyllis George.

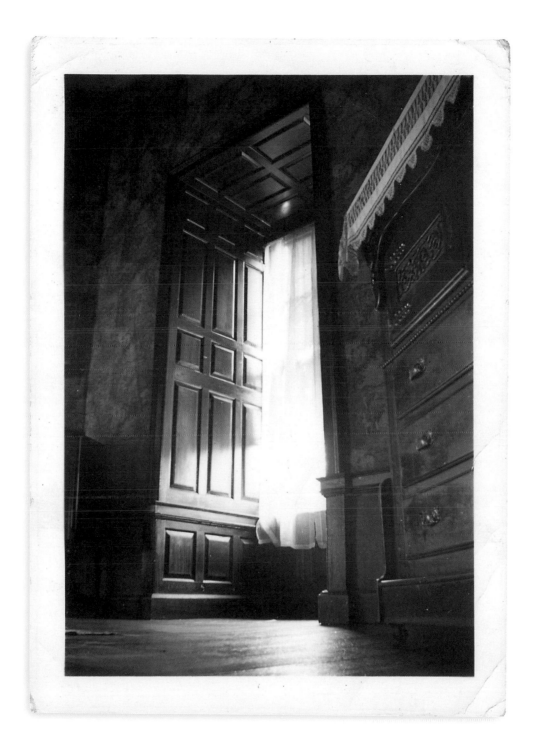

Chaumiere des Prairies was built by the English-educated Colonel David Meade of Prince William County, Virginia, who devoted himself to the entertainment of his guests. Surrounded by acres of perfectly groomed gardens, his log buildings were augmented in the 1820s by a brick wing containing this elegant octagonal parlor. Meade and his wife, who continued to dress in the fashion of the eighteenth century, received Henry Clay, James Monroe, Aaron Burr, Andrew Jackson, Zachary Taylor, and other distinguished figures of the day. The octagonal parlor still stands in Jessamine County, on Catnip Hill Pike.

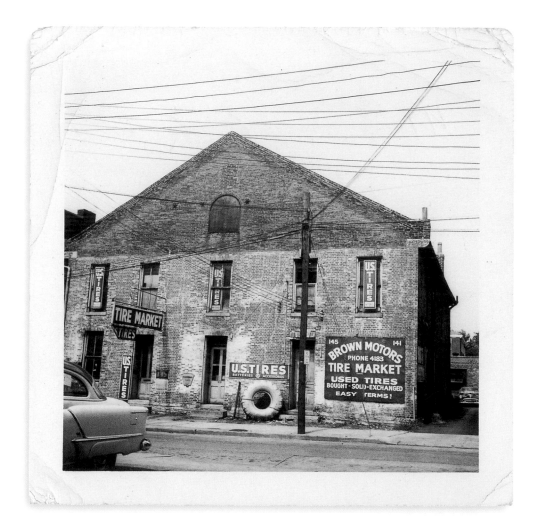

The Methodist Episcopal Chapel in Lexington, which gave Church Street its name, was built in 1822. After the congregation moved in 1841, the structure saw many uses, including as a meetinghouse, city hall, school, and tire company. It was razed in 1958.

One of the world's first railroad stations stood at the corner of Water (near Vine) and Mill Streets in Lexington. It was built in 1835 by John McMurtry, then age twenty-three. The third story was added around 1861. The train station was torn down for a parking lot in 1959.

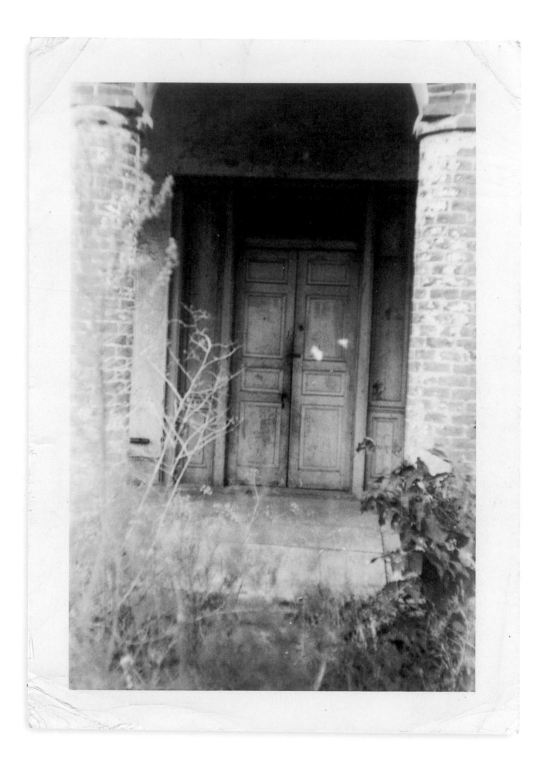

This doorway at Pleasant Lawn in Woodford County has been used on three separate visits by Queen Elizabeth II. Today, Pleasant Lawn is known as Lane's End Farm, the home of William Stamps Farish. Farish served as U.S. ambassador to Great Britain during the first term of President George W. Bush.

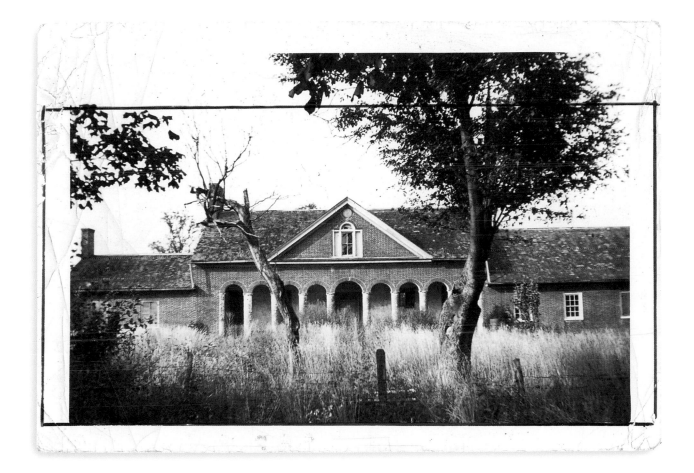

Daniel Jackson Williams built Pleasant Lawn in Woodford County in 1829. The facade shown here features a pedimented arcade with a Palladian window above.

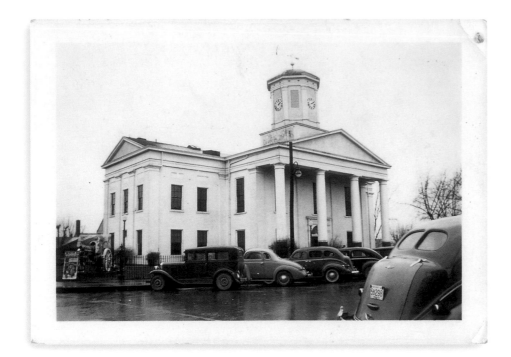

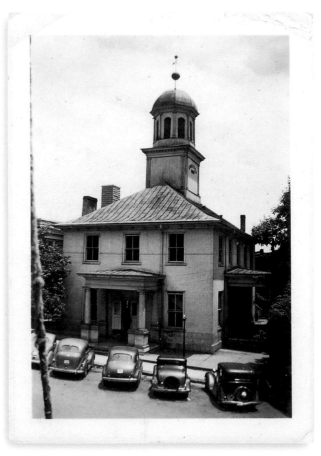

Two Kentucky courthouses—Harrison County at Cynthiana on 31 November 1941, and Washington County at Springfield in June 1940.

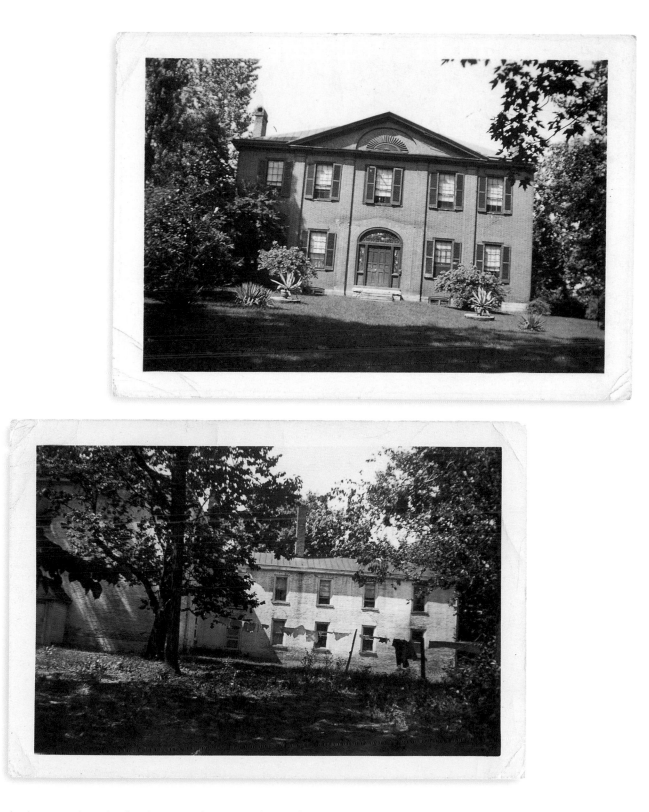

This house, in the style of architect Matthew Kennedy, stands at 312 Lancaster Avenue in Richmond. In this 1940 photograph, the original glass and leading of the doorway have been replaced with art glass of a later period. The ghost of a removed portico (probably a later addition) is plainly evident. The back section, or ell, of The Meadows, a Kennedy-style house built for Dr. Elisha Warfield in Lexington in the early 1830s, is shown. The Meadows was razed in the summer of 1960 to extend a subdivision.

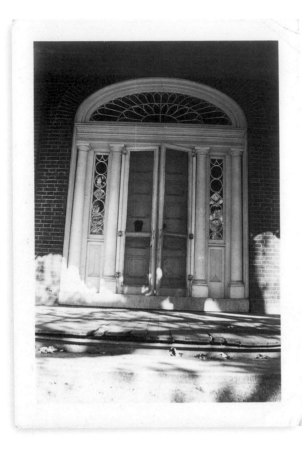

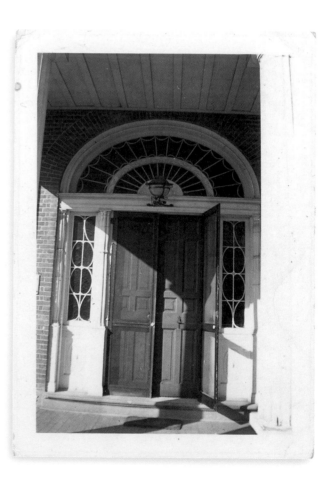

Kentucky's first professional architect, Matthew Kennedy, built more than half a dozen residences using a similar front facade. Each building exhibits subtle differences, as shown by these doors at Elkwood and the Samuel Wallace House (circa 1825), both near Midway in Woodford County. The Elkwood door has an elliptical fan supported by columns; the door at the Wallace House boasts a demilune fan supported by clustered colonettes.

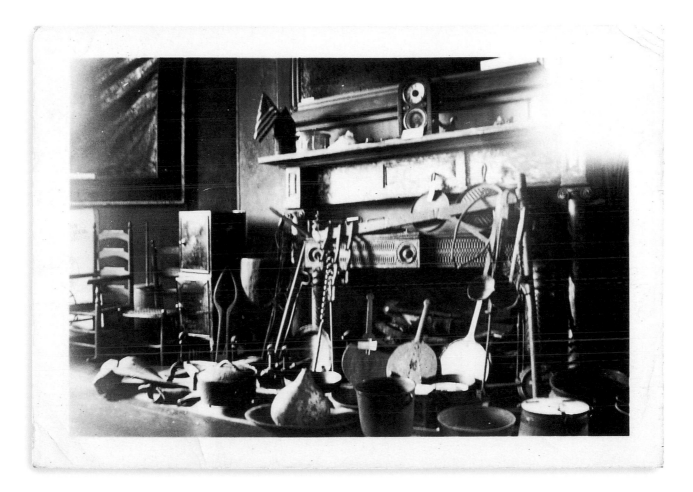

The lobby in the Greek Revival Old State House at Frankfort. The ornately carved mantel is elegant, but obscured by an exhibition of kitchen utensils.

The Jacob Ashton House was a Federal-period building once at 145 East High Street in Lexington. It was remodeled in the Greek Revival style in the 1830s, probably by Ashton's friend Gideon Shryock, architect of Transylvania University's Morrison Hall and the old capitol in Frankfort. For a time in the twentieth century, it served as the Little Inn. It underwent extensive improvements in 1941.

Improvements under way at the Jacob Ashton House on East High Street in 1941.

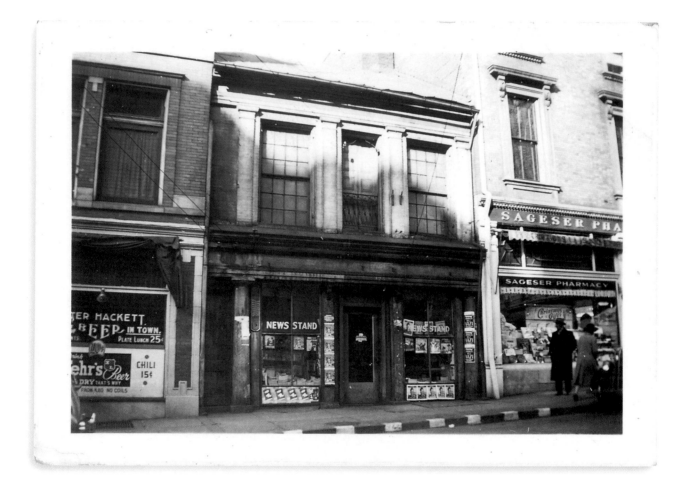

The confectionery of Monsieur Mathurin Giron of New Orleans, now at 125 North Mill Street, was built in 1836. It housed two shops below and two dining rooms or ballrooms above. Near the turn of the twentieth century, more than half the building was demolished, along with a delicate ironwork balcony. It is one of several Lexington buildings to be cut in half, along with Rokeby Hall at 318 South Mill Street and the Thomas Hart Noble House at 539 West Third Street.

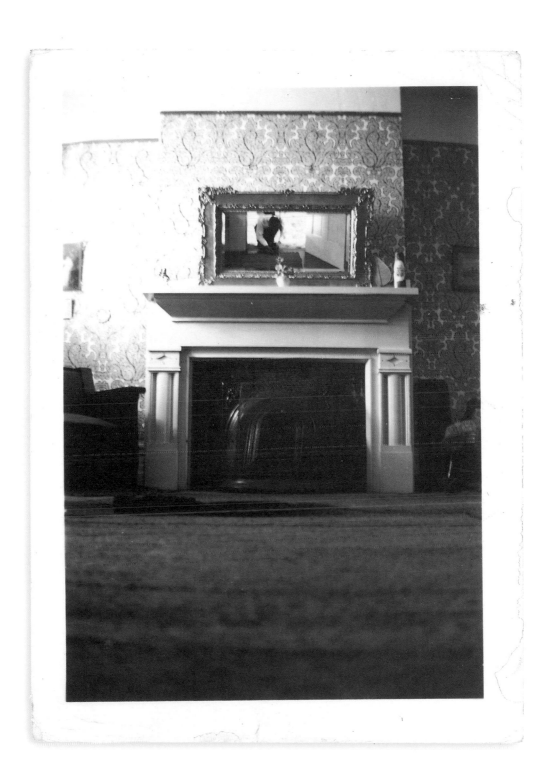

Clay Lancaster described the Burgess House in Mayslick, built by a banker, as "one of the oddest houses ever to have a porticoed front." While photographing the parlor mantel, Lancaster photographed himself in the overmantel mirror. In so doing, he revealed how he simply rested his camera on the floor, using no tripod or flash.

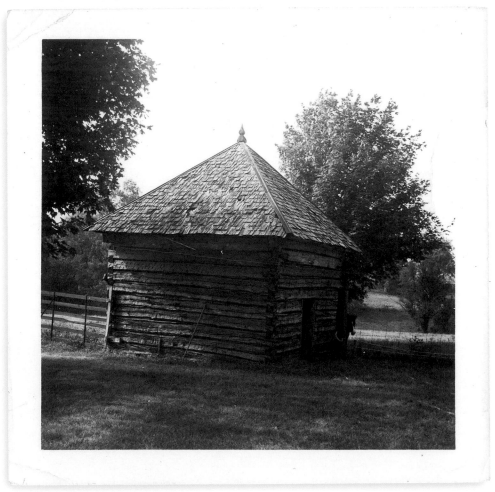

A pair of masonry dependencies at the Hamilton House near Bethel, and another one of similar outline but log construction at the Bowman House near Burgin. Cubic, with a pyramidal roof, such buildings were common in log, frame, and brick in both the eighteenth and nineteenth centuries.

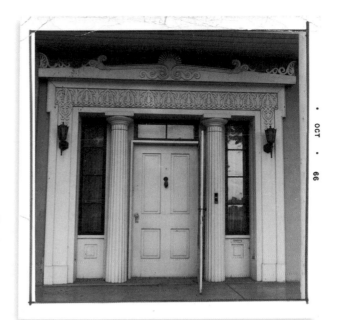

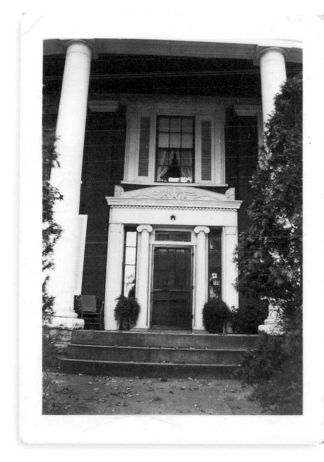

Two richly adorned Mercer County doorways of the Greek Revival era. The Doric passage, with the more ornate acroteria, is at Diamond Point in Harrodsburg and is derived from the manuals of Minard Lafever. The Ionic doorway is at Honeysuckle Hill, also in Harrodsburg. Both houses date to the 1840s.

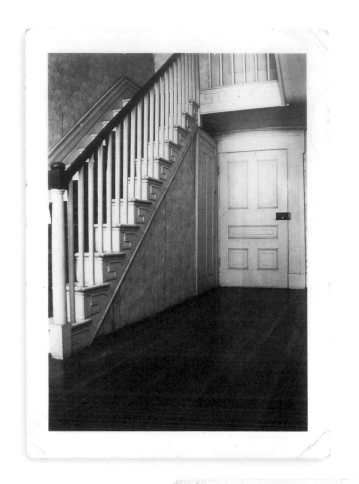

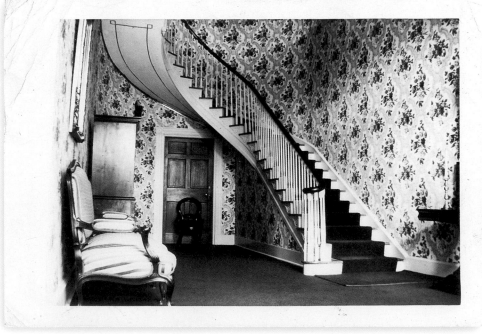

This rectilinear Greek Revival stair, with its bold Greek meander pattern, is at Belvoir, near Wilmore, and was photographed on 19 October 1940. It contrasts with the delicate Federal stair photographed at Grassland, in Fayette County, on 25 August 1952, one of a series of similar houses designed by Matthew Kennedy.

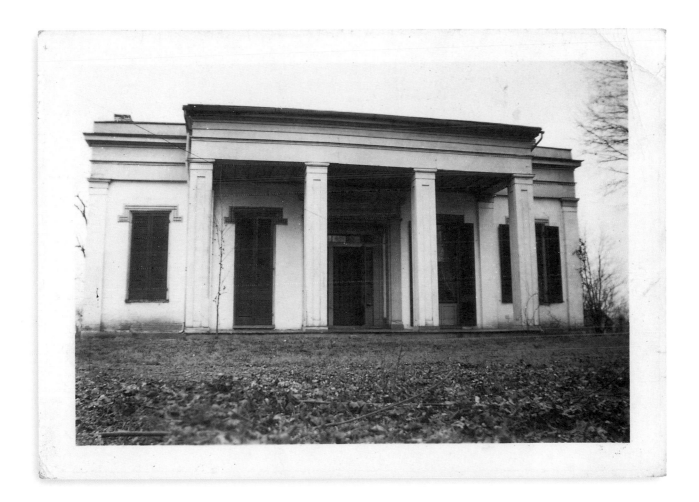

The Offutt House, which once stood on Oxford Pike in Scott County, shows a mixed architectural vocabulary—a Greek Revival structure with Gothic Revival label moldings above the windows.

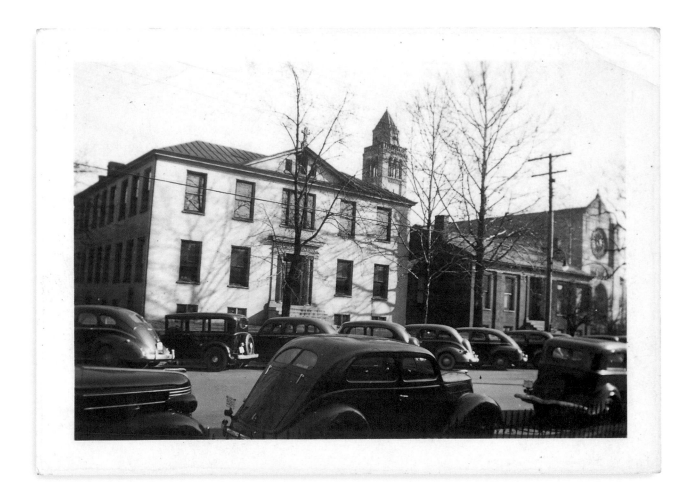

A view of Barr Street in Lexington in the 1940s. Between St. Peter's School at left and St. Peter's Church at right is the Greek Revival house of Francis Key Hunt, who later built Gothic Revival Loudoun. This house was demolished in 1953, although its fine doorway survives in the basement of a descendant of early occupants of the house.

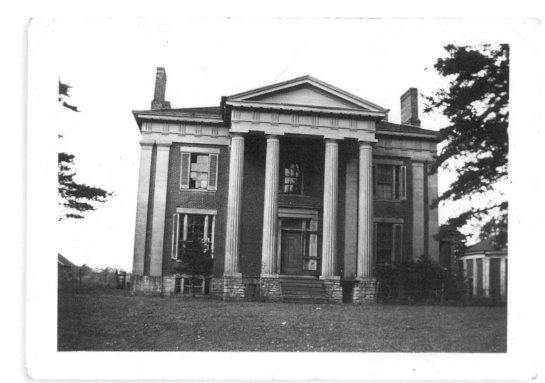

The William G. Craig House (1840s) in Scott County, also called Allenhurst, is a refined example of a Greek Revival dwelling. Each side displays a different pattern of brick masonry. The plaster medallion from the Craig House also occurs in other buildings of the period, including Elley Villa (twice) and Ward Hall (where it is painted in colors).

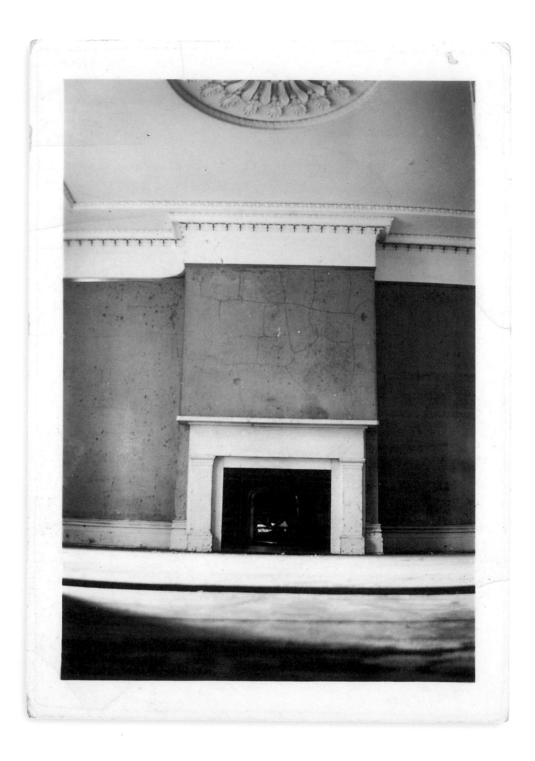

The parlor at the Craig House illustrates the severity of Greek Revival mantels. The simple form was a reaction to the highly ornamental carved mantels of the earlier Federal period.

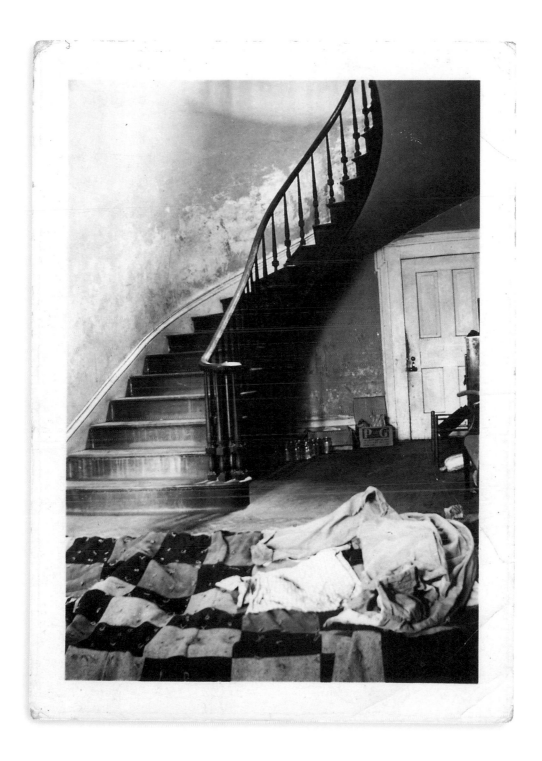

The curving stairway in the Craig House shows a handsome form, even during its days of disuse.

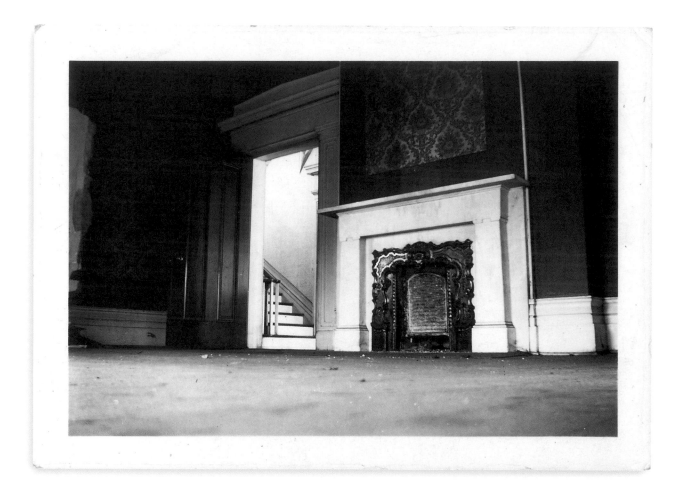

The dining room of Clay Villa, on Forest Avenue in Lexington, designed by Thomas Lewinski in the mid-1840s for Henry Clay's son James B. Clay. Clay Lancaster's photograph taken nearly a century later shows the original Greek Revival mantel, doorway, baseboard, and stair.

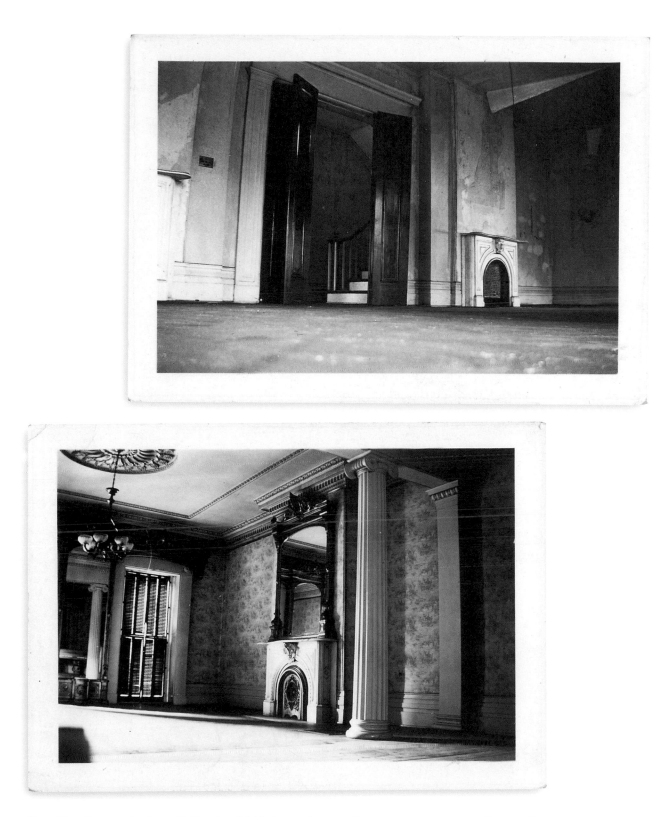

Clay Villa, photographed on 30 October 1940, featured a long drawing room with two arched marble mantels. The vast double parlor of the Tobias Gibson House on Second Street in Lexington, photographed on 14 November 1940, exhibited the original mantel brought up from Louisiana and the gilt overmantel and pier mirrors, as well as the gilt lambrequins of the mid-nineteenth century.

The Thomas January House, on Second Street in Lexington, was greatly enlarged in the Greek Revival mode by Tobias Gibson in the 1840s. This view of its roof shows octagonal chimneys added by architect John McMurtry.

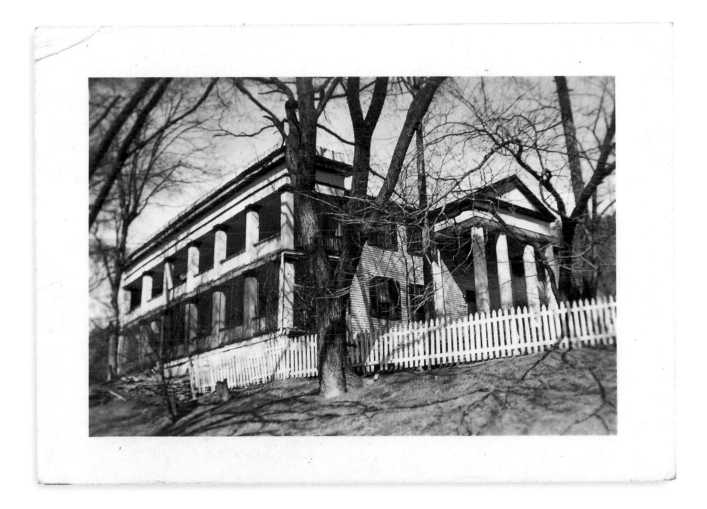

Mundy's Landing in Woodford County is the only Kentucky structure included in Clay Lancaster's *Architectural Follies* *in America* (1960). With its long colonnade suggestive of the early river steamboats, Mundy's Landing served as a hostelry on the Kentucky River. It had a ferry as well as a landing, thus serving both road and river travelers. In addition to operating their tavern, the owners mined calcite and feldspar nearby. Documentation for Mundy's Landing is uncertain, but the Greek Revival facade dates to Jeremiah Mundy and 1847; however, some aspects of the structure suggest work of an earlier period.

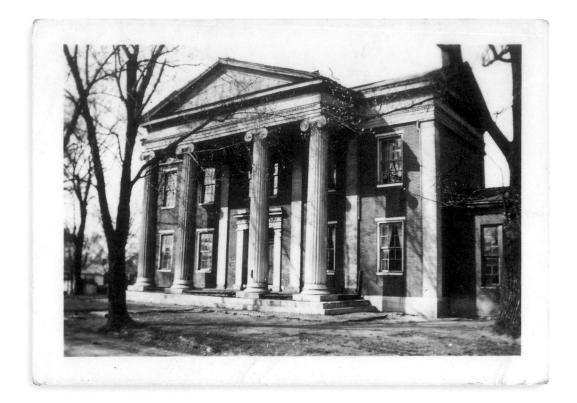

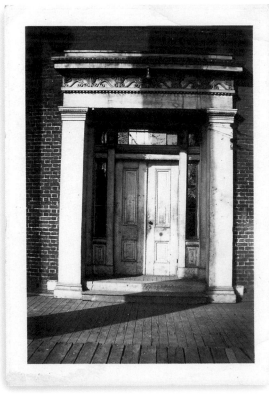

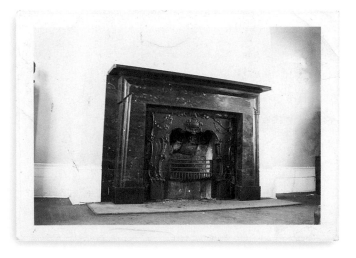

Rosehill, a high-style Greek Revival mansion opposite the city cemetery in Richmond, was built for Colonel William Holloway after 1849. It is a pilastered five-bay house with a colossal portico of fluted columns and Ionic capitals. Its doorway is adapted from Minard Lafever's *Modern Builder's Guide* (1833). The fine mantel in the left chamber shows the characteristic Greek Revival ears, and the tapered supports reveal the period's interest in Egyptian design.

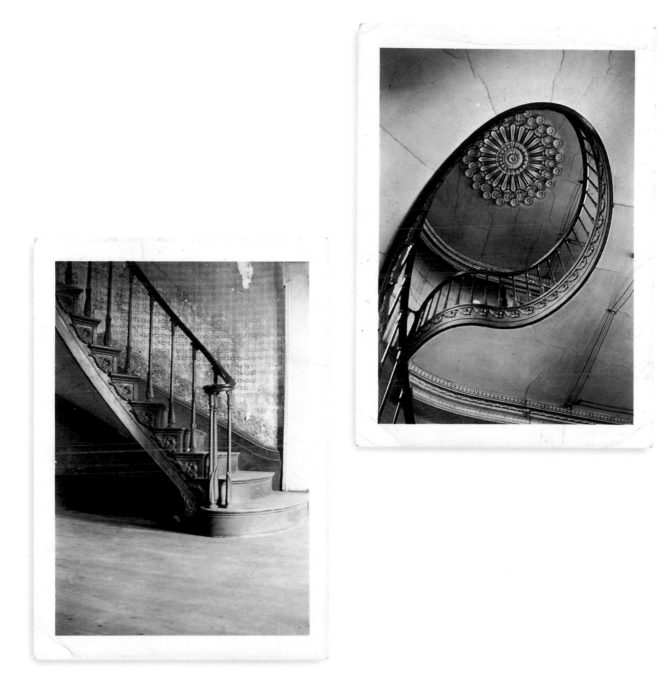

Clay Lancaster wrote of Rosehill, "The elliptical staircase in the main hall is a thing of beauty, its railing carried on finely shaped banisters of Egyptian inspiration, its consoles carved into a bird-leaf pattern, a great lion's paw forming the base of the stairway string, and the first few steps curving out gracefully. The circular plaster centerpiece is especially suitable here."

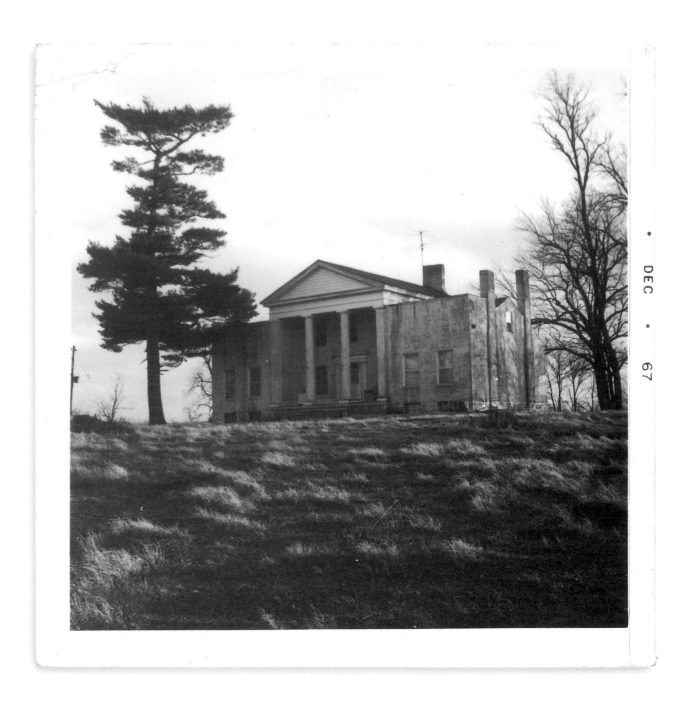

DEC • 67

Greek Revival in town and country *(above and facing page)*. This tavern on Leestown Pike was originally built as a residence for William W. Davis. It became a popular inn, frequented by politicians on their way to and from Frankfort. It was demolished in the 1990s.

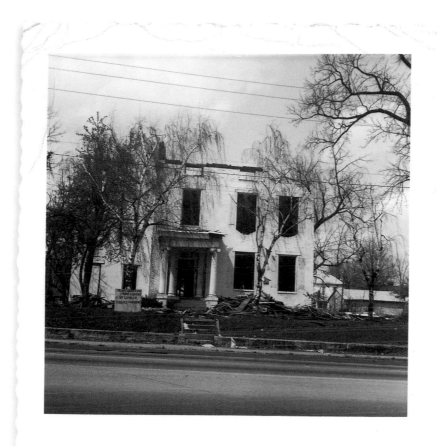

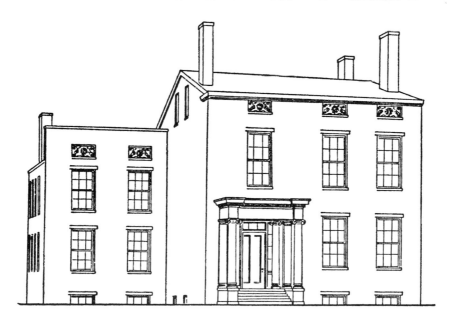

The photograph of the Butler House, a townhouse at 331 South Broadway in Lexington, was taken 3 April 1974. It shows the progress of Clem's wrecking service, which offered the salvage for sale. Clay Lancaster's drawing of the Butler House is from *Back Streets and Pine Trees* (1956).

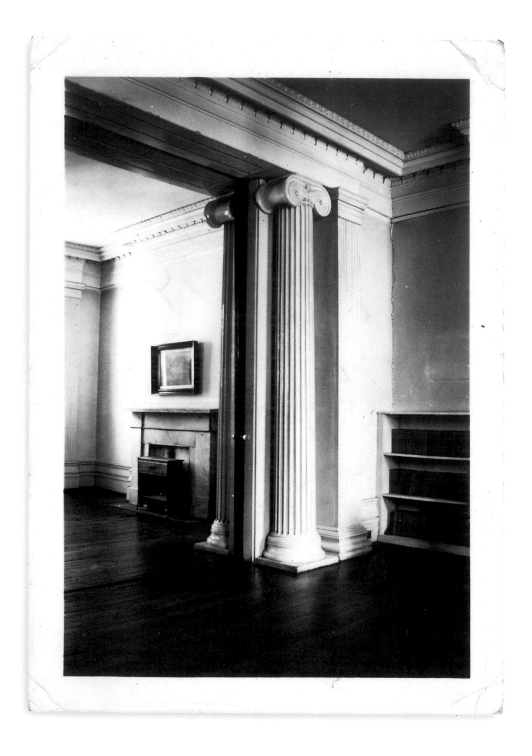

Above and facing page. The McCauley House in Lexington, built in the early 1850s, now stands behind the Maxwell Street Presbyterian Church. It is a finely detailed residence similar in form to Walnut Hall, and its handsome fluted pillar screen can be compared to the even more ornate interior of White Hall on North Limestone Street.

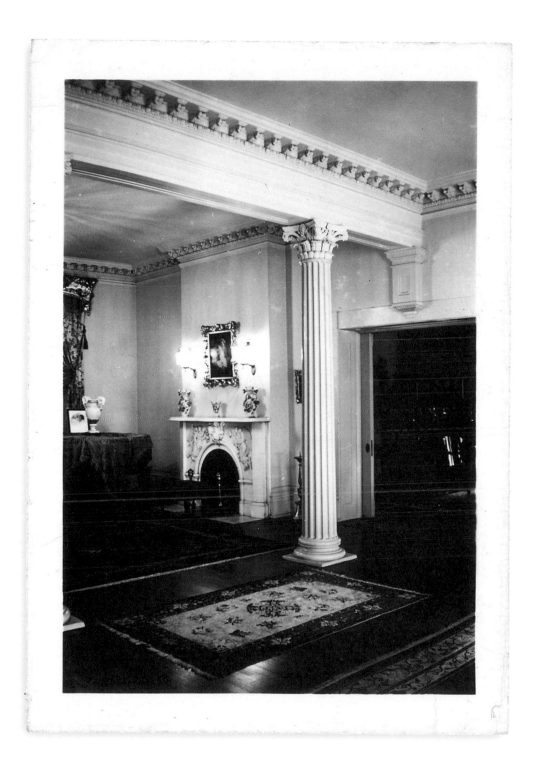

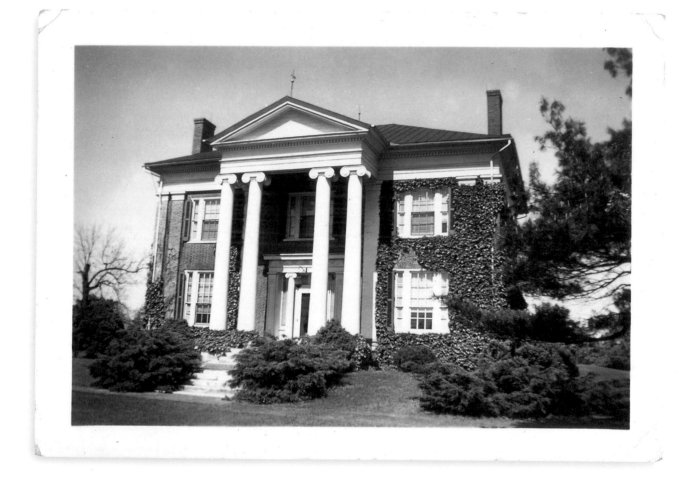

Castlelawn, the Benjamin McCann House on Old Richmond Road near Lexington, is a pilastered three-bay Greek Revival house attributed to architect John McMurtry. Like those of McMurtry's Corinthia, the ceilings of Castlelawn are 16 feet high.

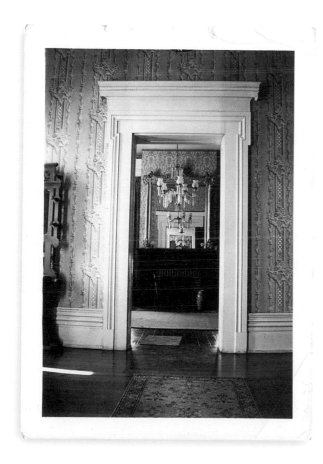

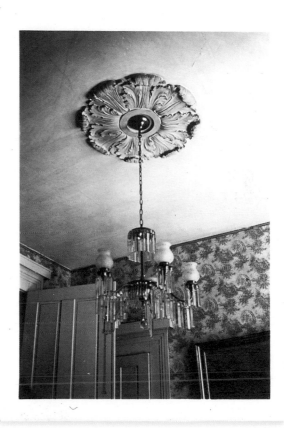

This view into a doorway at Castlelawn shows the infinite reflection of a chandelier between two overmantel mirrors—a delightful effect. A ceiling medallion from Castlelawn is also shown.

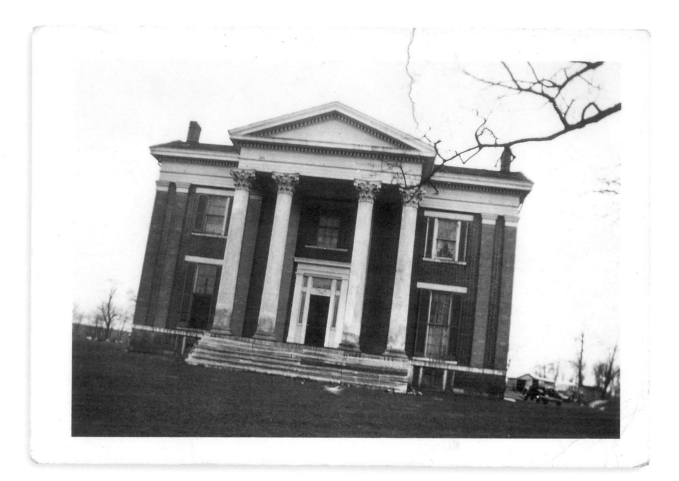

Above and facing page. Corinthia, the Greek Revival Charles Innes House on Russell Cave Road, was built by John McMurtry using a floor plan akin to that of Ingelside, a Gothic Revival house on Harrodsburg Road. These views were made in 1939, the medallion was photographed on 25 September 1940, and the elevation drawing is from Lancaster's book *Back Streets and Pine Trees* (1956).

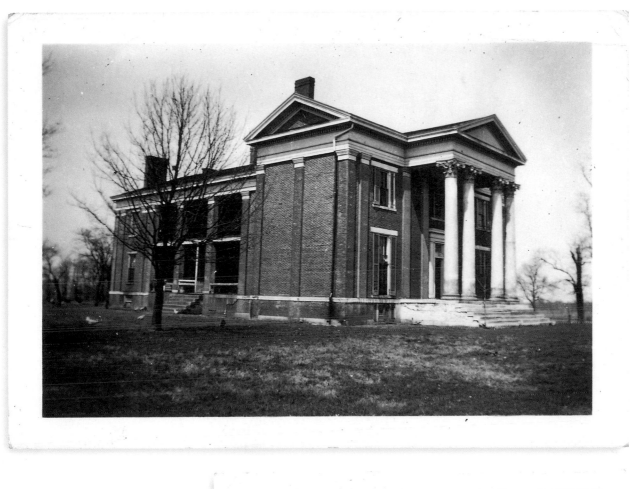

Details from two handsome entrance porticoes of the colossal Greek Revival type, photographed in September 1940: Corinthia, on Russell Cave Road in Fayette County, and the Chenault-Allen Tribble House in Madison County.

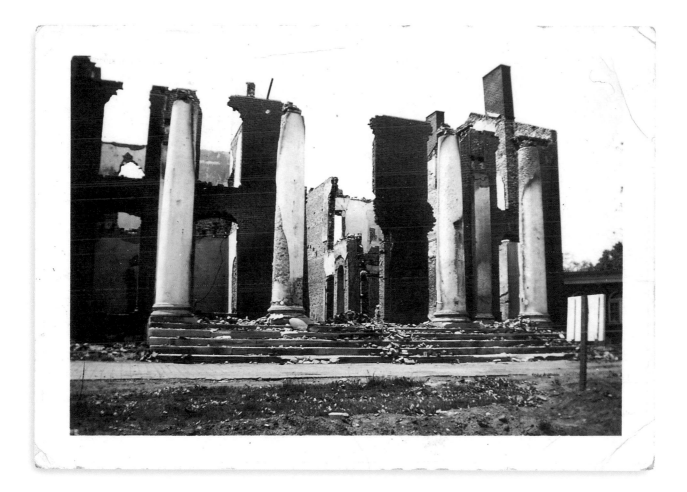

Here resembling the ruins of Greece and Rome, The Elms, one mile south of Lexington, was built by John McMurtry for William Leavy sometime before 1854. It later became McMurtry's own home. The Elms burned in 1940. A statuary niche can be seen in the center of the photograph.

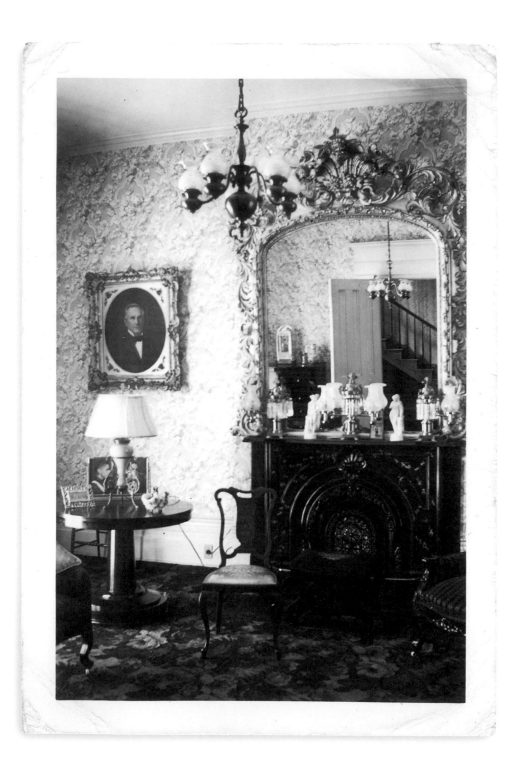

This interior of Auvergne, photographed on 25 August 1952, shows a magnificent overmantel mirror of the neo-rococo style and an oval picture frame of the same era. The house still stands on Tates Creek Road at Alumni Drive in Lexington.

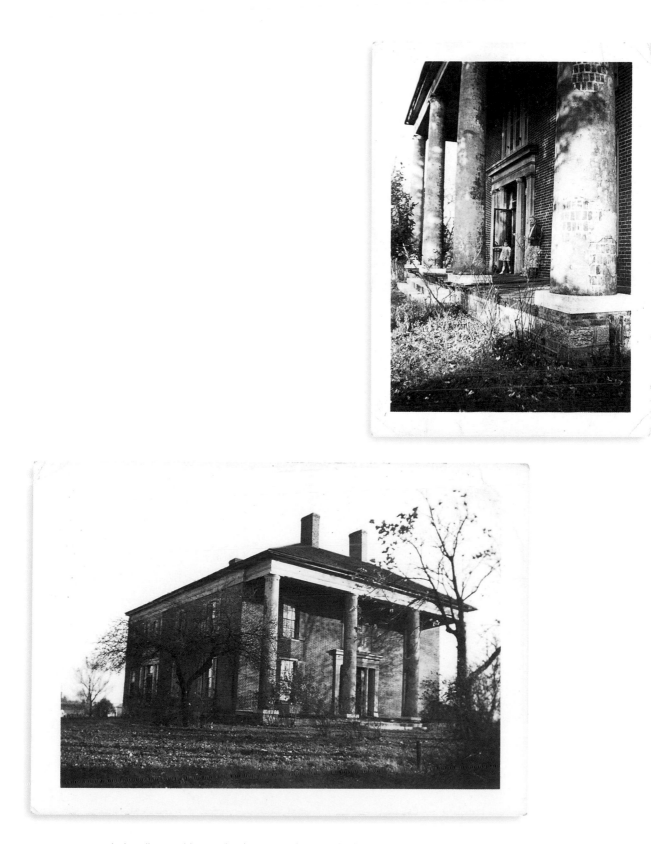

Fairview, on Nicholasville Road beyond Ash Grove Pike, was built circa 1850 for Dr. Lewis Marshall, youngest brother of Chief Justice John Marshall. It was later sold to Daniel Boone Bryan II. The masonry is Flemish bond. Fairview is one of the few Jessamine County houses with a colossal portico extending across its entire front. The house is shown in the 1940s.

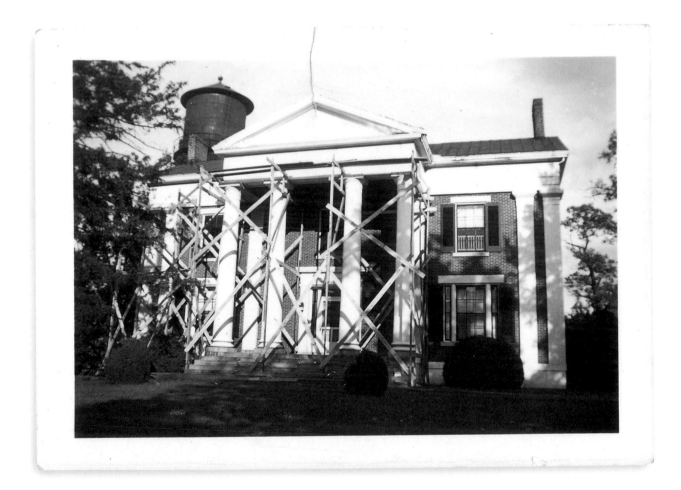

Buenna Hill, on Russell Cave Road, was built in the late 1840s by John McMurtry for Robert Innes. It stands opposite Corinthia, built for Robert's brother Charles. Here it is shown undergoing renovation on 25 September 1940.

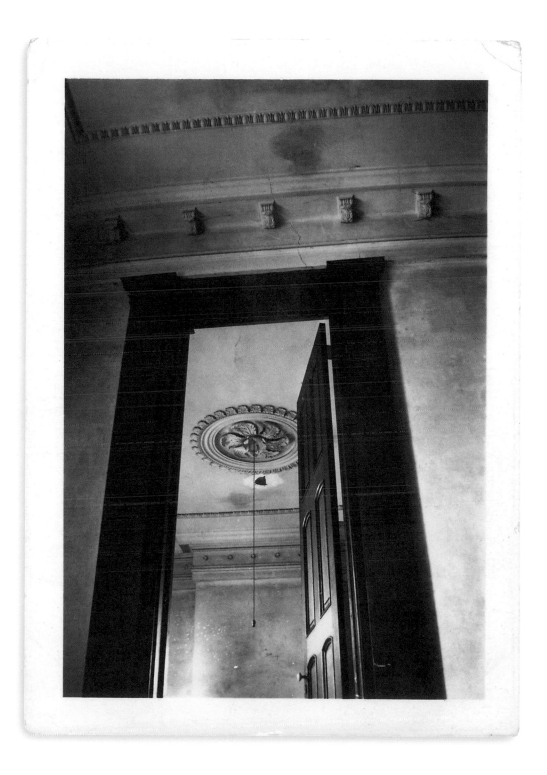

Clay Lancaster photographed Mauvilla, a grand Greek Revival residence near Westport in Oldham County, in February 1941. Built in the mid-1850s, it was demolished a century later.

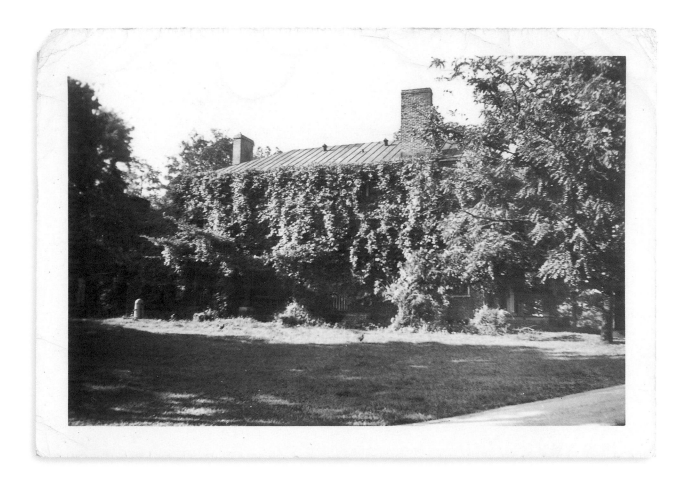

Belair, on Walnut Hill Pike in Fayette County, was the Greek Revival residence of turfman Brownell Combs (1885–1973). Clay Lancaster photographed Belair on 25 August 1952. The luxuriant vines recall the quaint fashion of "house as trellis," a popular Victorian practice. Combs was a lifelong admirer of Lexington-born Countess Mona Bismarck and named a horse after her.

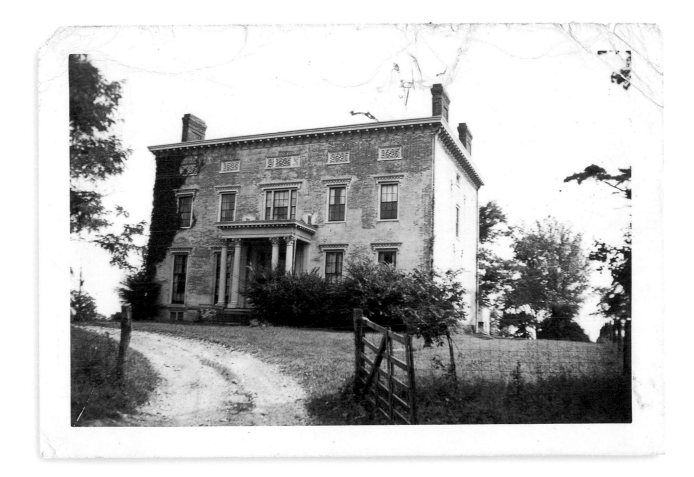

Richland, on Old Richmond Road, was built by William Bury Kinkead and his wife Elizabeth Shelby, daughter of Thomas Hart Shelby of Grassland. It is one of several Shelby houses in the Fayette County area. (An earlier Richland was built here for General James Shelby, son of Governor Shelby and brother of Thomas Hart Shelby.)

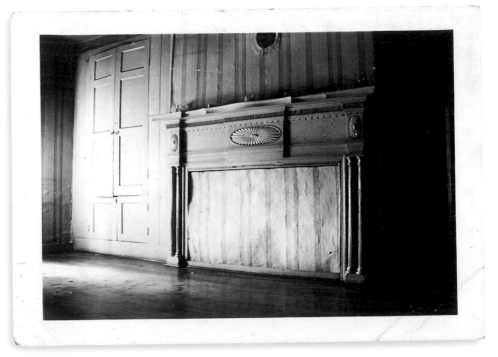

102 A stuccoed pillar on cut stone at Belvoir, near Wilmore in Jessamine County, along with a disused early mantel.

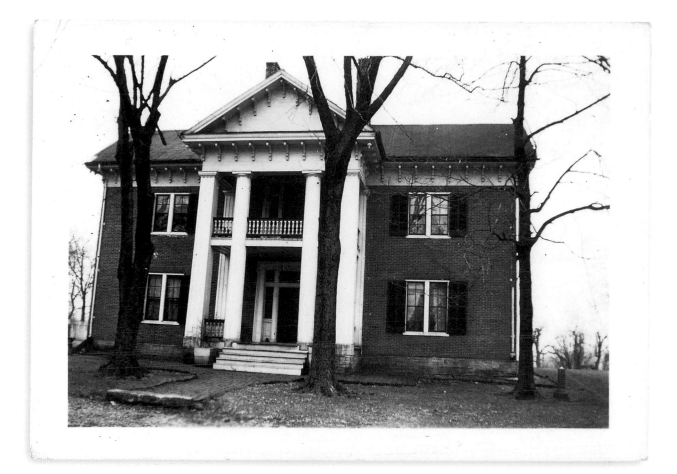

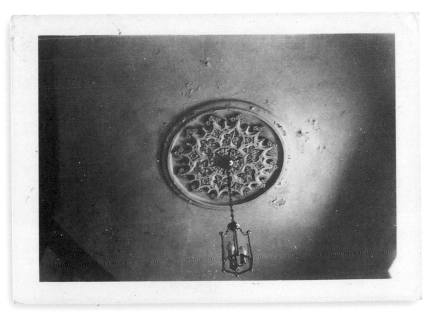

The John Stout House stands on Pisgah Pike in Woodford County. Greek Revival in its overall form, it displays Italianate brackets at the eaves and a Gothic Revival medallion and lantern in its entrance.

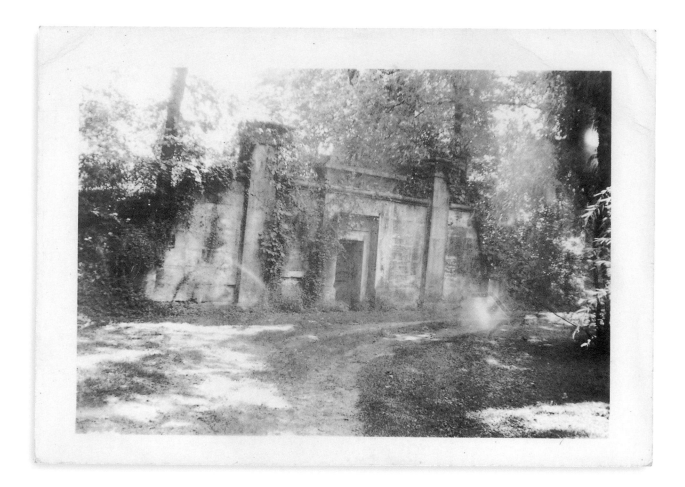

The receiving vault at the Lexington Cemetery was built in 1857. It exemplified the Egyptian style then popular in northeastern cemetery design. The vault was demolished in the 1950s.

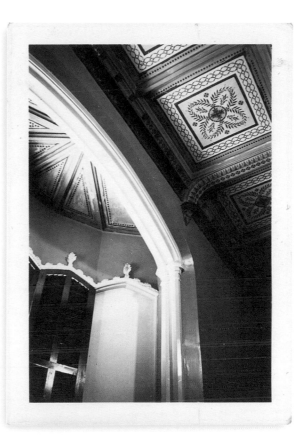

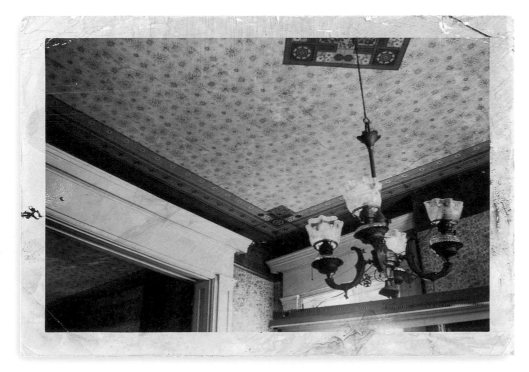

Although many houses of the nineteenth century had cast plaster ornamental moldings, here are two exceptions. Gothic Revival Loudoun House in Lexington had modish stenciled patterns in the coffered ceiling of its parlor, photographed 2 April 1941. The Charles Gentry House on the Sulphur Well Road in Fayette County, photographed 29 August 1952, employed a decorative papered ceiling, with a paper medallion for the chandelier.

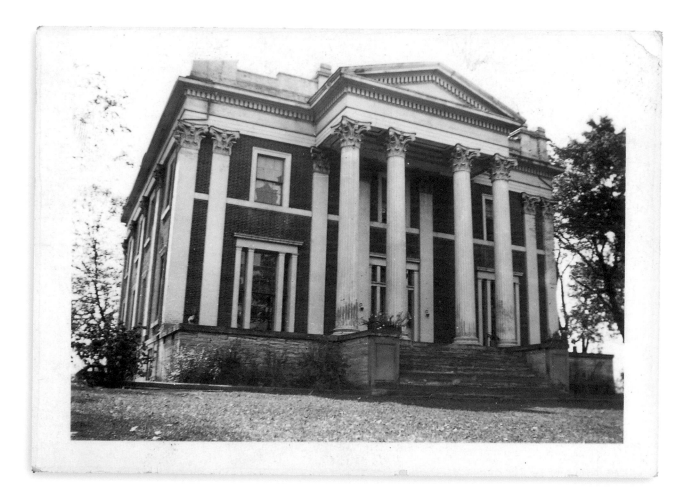

The grandest Greek Revival house in Kentucky, and one of the grandest in America, is Ward Hall in Scott County. It was built for Junius Ward, who lived both at Ward Hall and a house in Princeton, Mississippi. Ward Hall is similar enough to Woodside, the original version of Lexington's Bell House, to suggest that Thomas Lewinski was its architect. (Bell House was remodeled in the 1880s by Cincinnati architect Eugene Desjardins.)

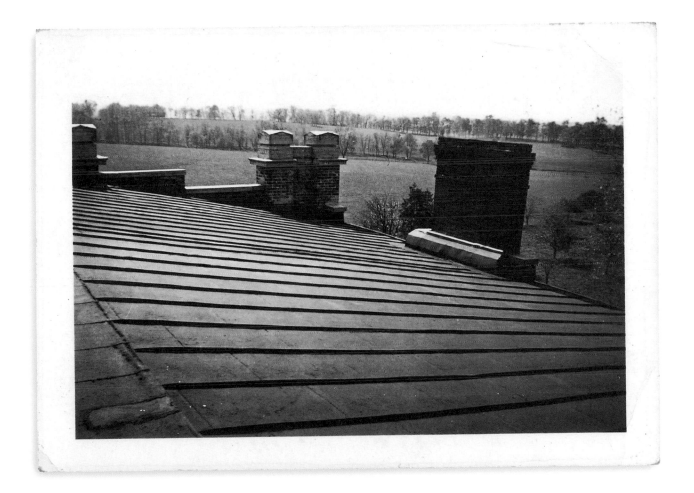

A view of the Scott County countryside from atop Ward Hall. The original copper roof was removed and sold during the Civil War.

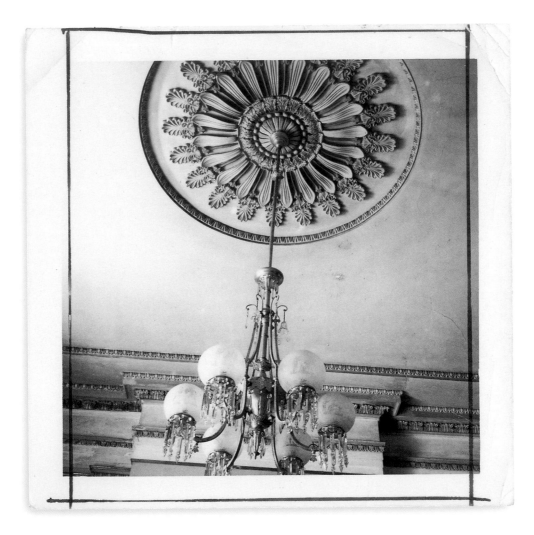

108 Ceiling medallion with anthemion above a crystal chandelier at Ward Hall.

This doorway at Ward Hall gives an alluring view of the gracefully curving formal stair. The simple stair that rises to the roof of Ward Hall is nevertheless fronted by a high-style doorway copied from a formal pattern book by Minard Lafever. Both were photographed in October 1940.

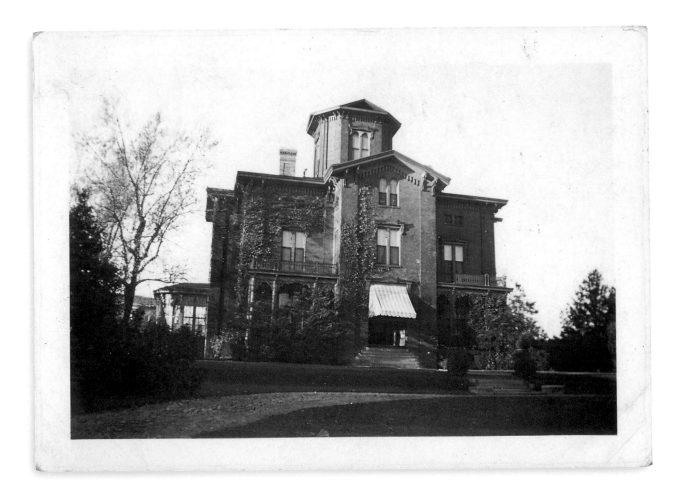

Above and facing page. The most dramatic interior space in antebellum Kentucky was planned for Lyndhurst in Lexington, an Italianate villa begun just before the Civil War but not completed until afterward. Based in part on a plan by Philadelphian Samuel Sloan, Lyndhurst's scheme was enlarged and elaborated by local architect John McMurtry. Lyndhurst was beautifully maintained until it was wrecked in 1964.

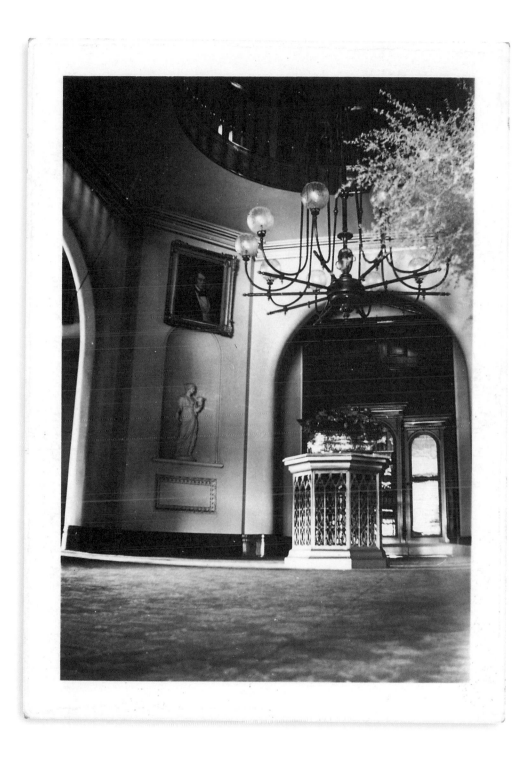

Lyndhurst's facade as drawn by Lancaster and spatial analysis of Lyndhurst showing the relation of inner space to outer form. Both drawings were published in *Back Streets and Pine Trees* (1956).

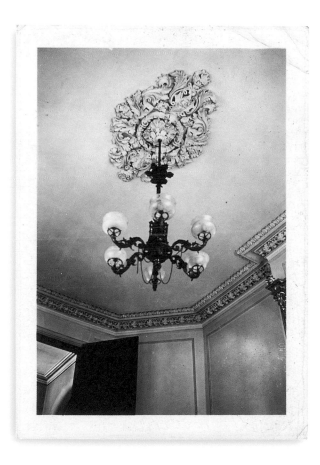

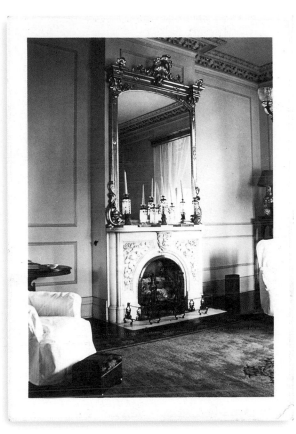

A richly ornamented marble mantel and overmantel mirror decorate the polygonal west parlor of Lyndhurst. Its gasolier hangs below a finely molded medallion and is surrounded by intricate cornices.

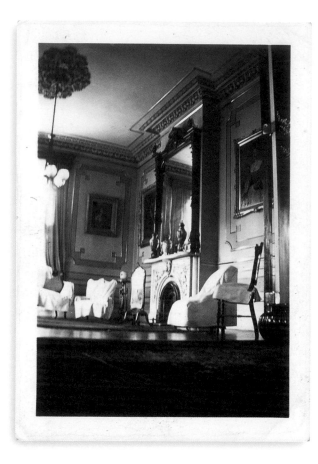

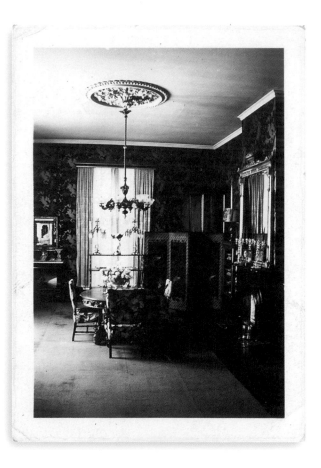

A Lyndhurst parlor in summer dress, and the dining room as it looked in the 1940s.

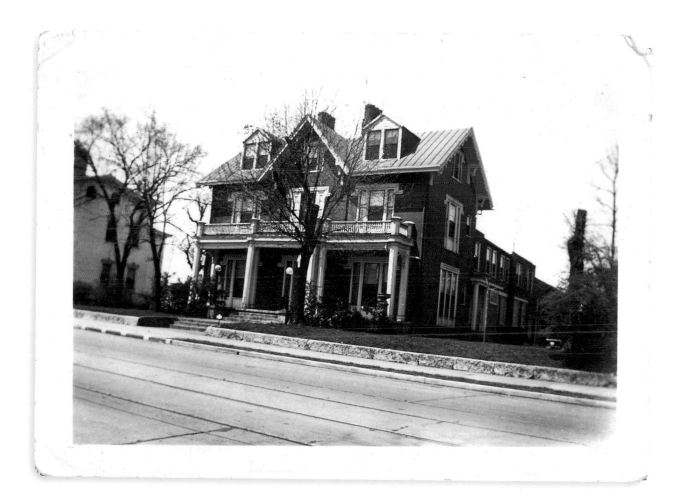

Clay Lancaster credits John McMurtry with popularizing the Gothic Revival style as a residential form in central Kentucky. Here is an early essay, a house that McMurtry built for himself circa 1846 at 343 South Broadway in Lexington. An early stereopticon slide, now in the Lexington Public Library, preserves many of the original attributes of the building, which, as this later photograph shows, was altered over the years. The front bargeboards were removed, dormers pierced the front roofline, the tall chimneys were cropped, casements were replaced by sashes, Gothic tracery in the banisters above and below was lost, and bay windows vanished from the ends. After McMurtry's residency, the house became the Jackson Female Seminary and later a rooming house called the Britling. It was demolished in 1961.

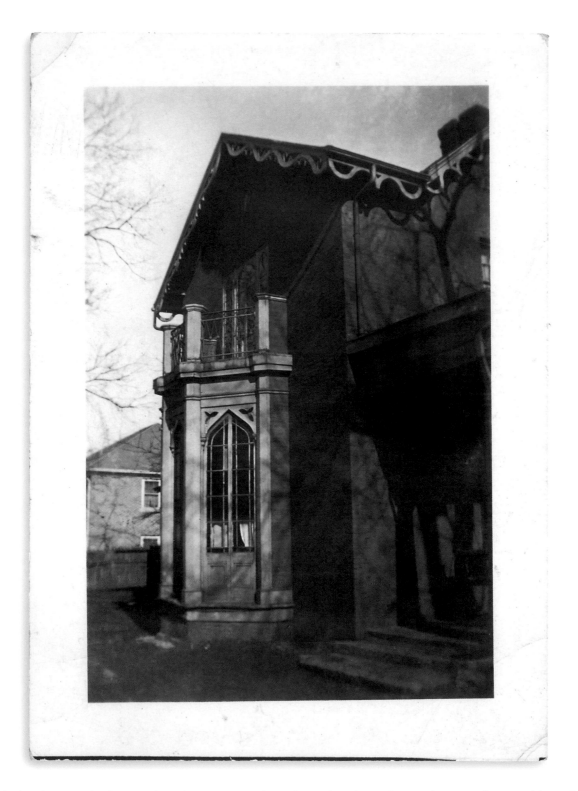

The handsome Gothic bay window above was on a house located on Spring Street in Lexington, between Maxwell and High. It was demolished to provide parking for the Civic Center. Also shown at right is the gilded Gothic Revival mirror removed from Loudoun House by Mrs. Francis K. Hunt when she moved to the Dudley House in Gratz Park.

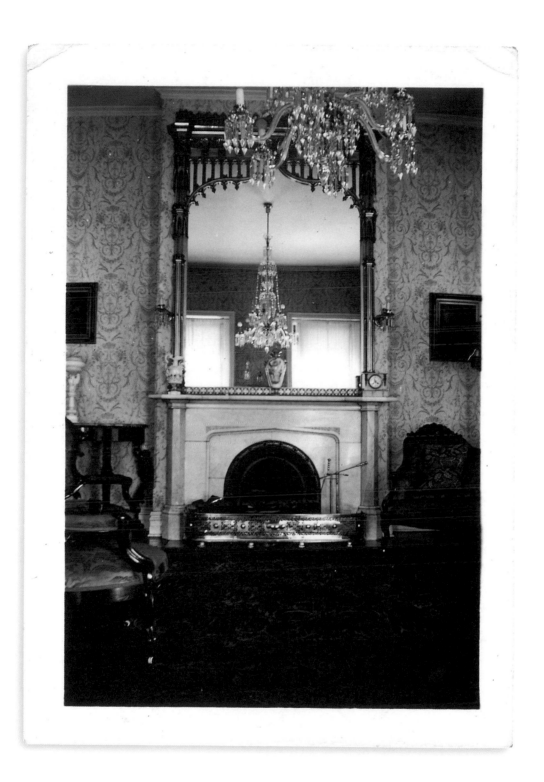

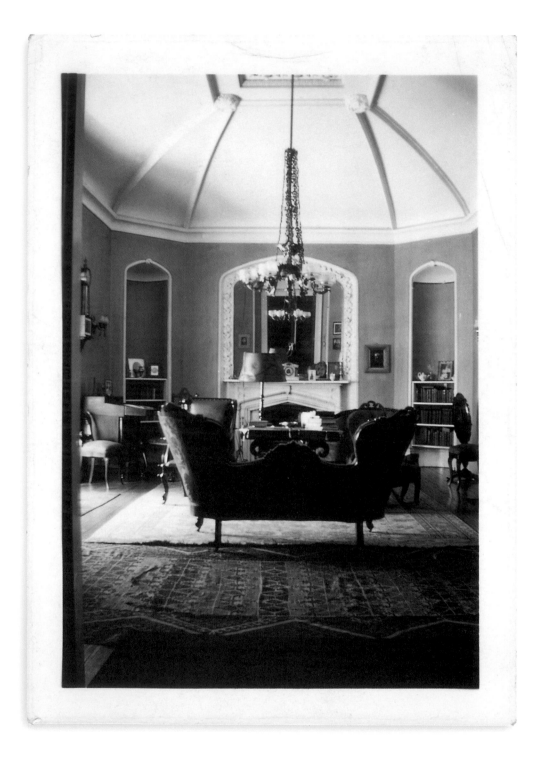

The Gothic parlor at Botherum on Madison Place in Lexington, a house designed by John McMurtry for Madison C. Johnson. It conceals a Gothic Revival interior within a Greek Revival exterior.

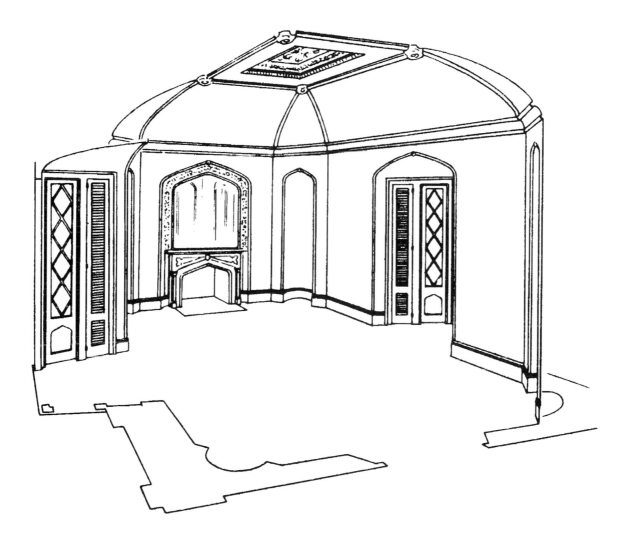

Cutaway view into the drawing room of Botherum. Drawing by Clay Lancaster from *Ante Bellum Houses of the Bluegrass* (1961).

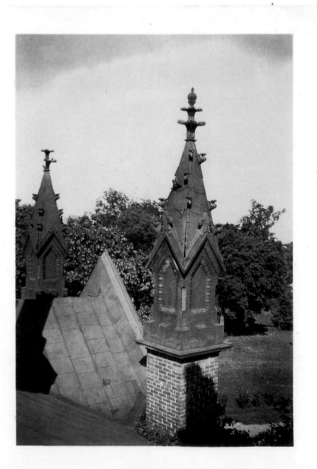

Gothic detail decorates this parlor medallion from the castellated villa Ingelside, designed by John McMurtry after a European tour and completed in 1852. The house, which stood on what is now South Broadway in Lexington, was conceived by Joseph Bruen for his daughter Elizabeth, who wed Henry Boone Ingels. Bruen's iron foundry cast the ornamental pinnacles seen from a tower on the south side of the house. For many years, Ingelside was occupied by the Gibson family, but it was demolished in June 1964 to enlarge a trailer park. Its gatehouse still stands, opposite an Atlanta Bread Company store.

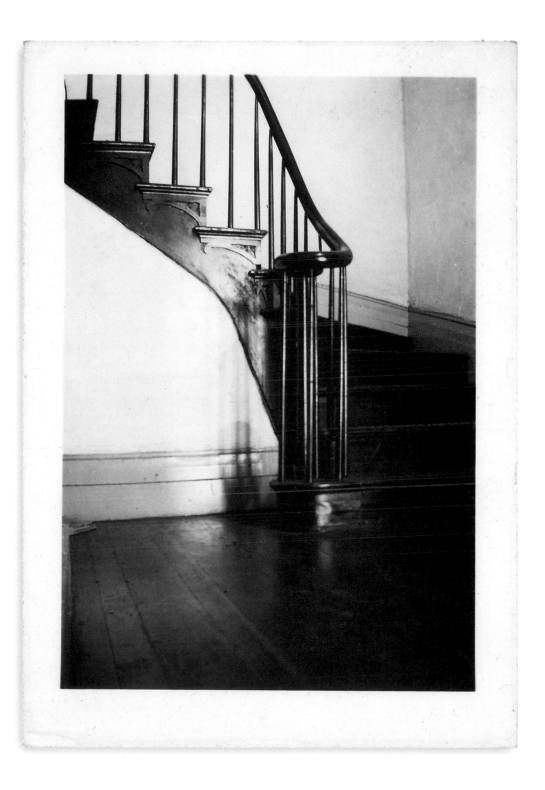

The newel for the stair at Ingelside. **121**

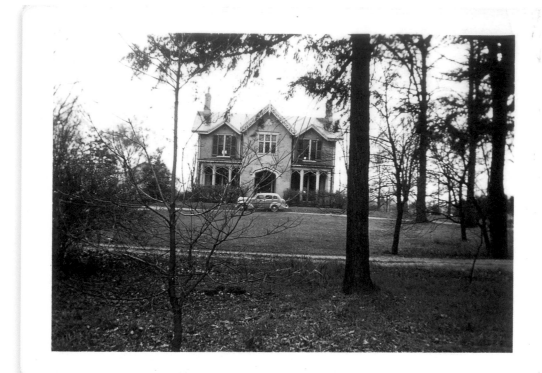

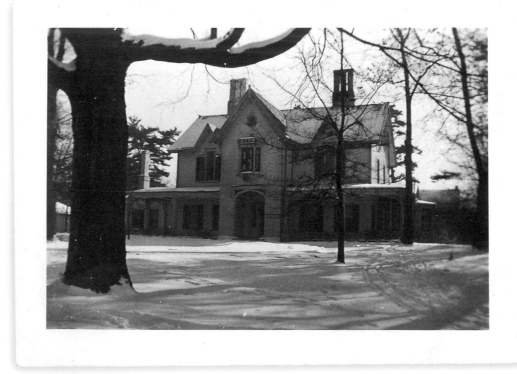

Hidaway in Paris and Elley Villa in Lexington, both built by John McMurtry, are examples of the "pointed" style of Gothic Revival architecture. Hidaway originally featured an oriel window over its entrance. Elley Villa, based on a plan by A. J. Downing, is treated in articles by Clay Lancaster in *Magazine of Art, Art Quarterly,* and *Journal of the Society of Architectural Historians.* Built for the niece of Vice President Richard M. Johnson, it was originally approached from a gateway at the corner of Rose and Maxwell Streets.

Facade of Elley Villa, as drawn by Clay Lancaster and published in *Back Streets and Pine Trees* (1956).

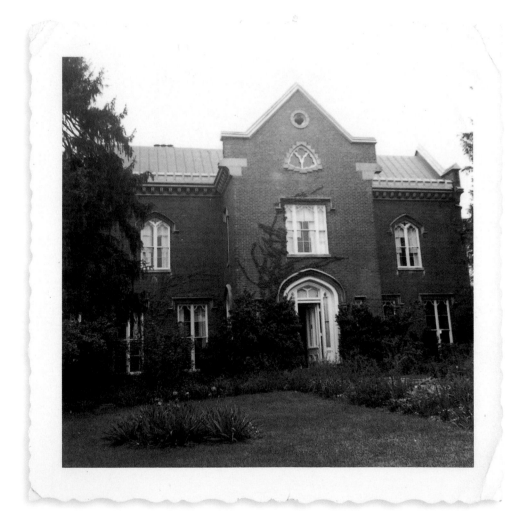

124 Buffalo Trace, at Maysville, was built for William Henry Wadsworth during the Civil War. A late example of the pointed style of Gothic building, its exterior is based loosely on the designs of A. J. Davis and A. J. Downing. It features parapets rather than bargeboards but displays label moldings characteristic of the Gothic mode. The building was photographed in May 1967.

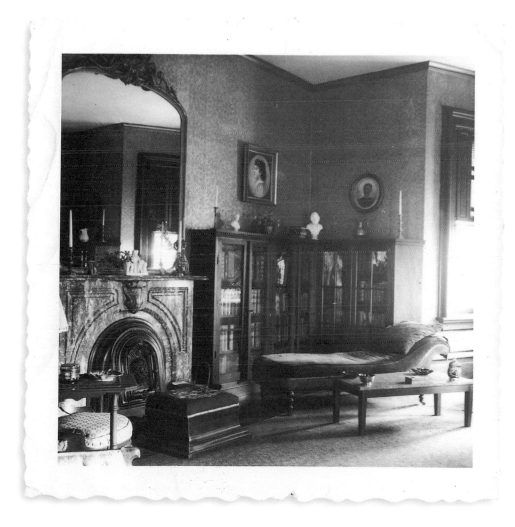

An interior view of Buffalo Trace, showing the brown marble mantel of the period and a gilt-framed overmantel mirror.

A garden dependency at Buffalo Trace repeats the Gothic-style label molding of the residence over its entryway.

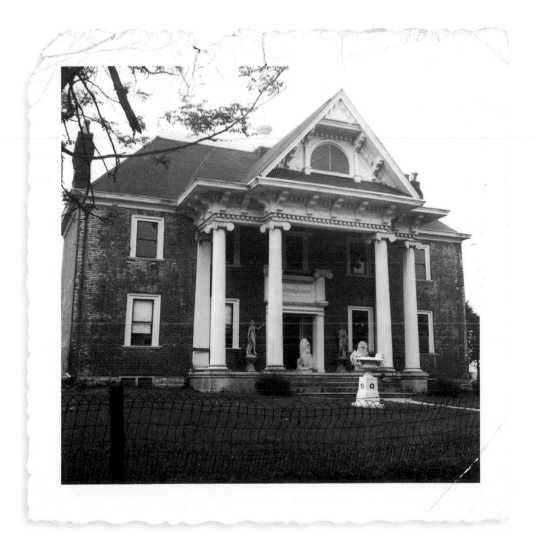

Lynnwood, near Danville, is an engaging example of architectural eclecticism. A roofline of the Second Empire rests over a classical facade fronted by an exuberant Ionic portico with a projection supporting a fanlighted gable garnished with late Victorian ornamentation. The deep and bracketed eaves recall the Italianate style but are reconciled with classicism by the rhythm of bold modillions. An original over-door treatment centers the architectural design, while classical sculptures and urns complete the decorative composition. The picture dates from 26 April 1967.

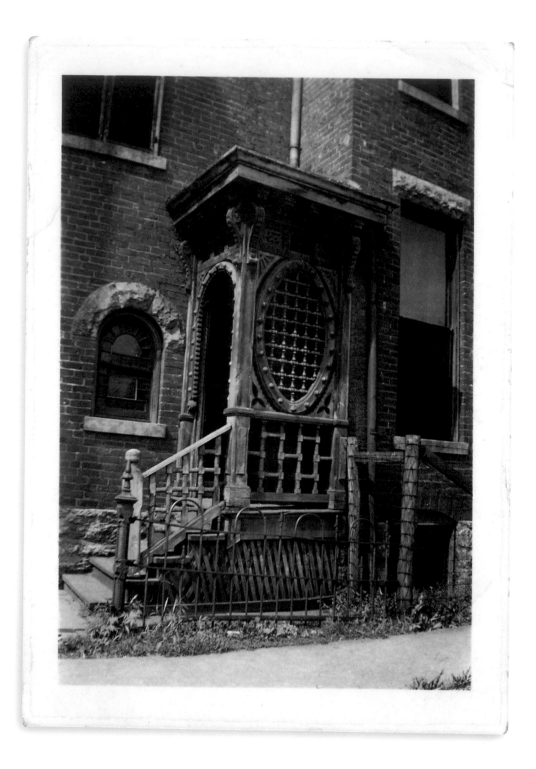

Renaissance Revival millwork here suggests the iron grilles on a Florentine palazzo of the sixteenth century. This is the back door of the house at North Eastern Avenue and Wilson Street in Lexington that belonged to Madam Belle Brezing. The doorway was photographed in August 1940, coinciding with her death. The house burned on 12 December 1973 and was bulldozed in the spring of 1974.

BOOKS BY CLAY LANCASTER

Back Streets and Pine Trees: The Work of John McMurtry (1956)

Architectural Follies in America (1960)

The Periwinkle Steamboat (1961)

Old Brooklyn Heights: New York's First Suburb (1961)

Ante Bellum Houses of the Bluegrass (1961)

The Japanese Influence in America (1963)

Michiko, or Mrs. Belmont's Brownstone on Brooklyn Heights (1965)

Prospect Park Handbook (1967)

The Architecture of Historic Nantucket (1972)

The Far-Out Island Railroad, Nantucket's Old Summer Narrow-Gauge (1972)

New York Interiors at the Turn of the Century (1976)

Greek Revival Architecture in Alabama (1977)

Vestiges of the Venerable City: A Chronicle of Lexington, Kentucky (1978)

Nantucket in the Nineteenth Century (1979)

Eutaw: The Builders and Architecture of an Ante Bellum Southern Town (1979)

The American Bungalow, 1880–1930 (1985)

The Incredible World's Parliament of Religions (1987)

The Flight of the Periwinkle (1987)

The Toy Room (1988)

Figi (1989)

The Inception of Universal Ethics in Ancient Asia and Modern America (1990)

Antebellum Architecture of Kentucky (1991)

The Runaway Prince (1991)

The Arts and Crafts of the Animals (1993)

The Crucified Joshua and the Resurrected Jesus (1993)

Dharmapala's Key to Religion (1993)

Holiday Island: The Pageant of Nantucket's Hostelries and Summer Life (1993)

The Blue Plaid Riders, or the Candy Shop Kidnapping (1994)

The Breadth and Depth of East and West (1995)

Architectural Edification (1996)

Architectural Exotica (1997)

From Ur to Uncle Remus: 5000 Years of Animal Fable Illustrations (1997)

Architectural Domestication (1999)

Architectural Residuum (2000)

Pleasant Hill: Shaker Canaan in Kentucky (2000)